Creation of Keringke Rockhole

This is a story about a kangaroo that came from the south-east in the Dreamtime. It was a big red kangaroo (*aherre*). He went behind Santa Teresa (Ltyentye Apurte), along the creek (*lhere*). As he was going through the country, he visited his cousin, the bellbird (*kwepalepale*). The place was really green, a smooth yellow vine (*ayepe*) grew ankle-high everywhere. The kangaroo travelled along the creek, he was careful not to get his feet caught in the vine. After he visited his cousin, he crossed a plain and got caught in the yellow vines. His leg became tangled up. He tried to drag himself up a gully, but because it was a hot day, he couldn't go any further. He stopped in a clear area, but there were too many flies. He threw dust over himself to keep them away. As he did this he made a big hole and that became a rockhole. When the vine dried up, he was free and hopped away to the north, leaving his footprints on the rock. These can still be seen today. From that time, hill kangaroos or euros (*arenge*) have come down to drink at the rockhole, and you can see their tail tracks there. Near the rockhole is a small pouch (*apethe*) with two shiny little pink stones in it, they represent baby kangaroos. After the big red kangaroo left his footprints, the rockhole became Keringke, which is a sacred site.

Keringke

Contemporary Eastern Arrernte Art

Keringke Arts

a *jukurrpa* book
First published in 1999 by
IAD Press
PO Box 2531
Alice Springs NT 0871
Ph: (08) 8951 1334
Fax: (08) 8952 2527
E-mail: iadpress@ozemail.com.au

Keringke Arts
Santa Teresa, via Alice Springs, NT 0872
Ph/fax: (08) 8956 0956

National Library of Australia Cataloguing-in-Publication data:

Keringke Arts Centre.
Keringke: contemporary eastern Arrernte art.

ISBN 1 86465 007 9.

1. Aborigines, Australian – Northern Territory – Santa Teresa – Art. 2. Aranda (Australian people) – Art. 3. Santa Teresa (NT) – History. I. Title.

704.039915

Designed by Louise Wellington
Map by Brenda Thornley
Colour plates and artists' portraits by Steve Strike (Outback Photographics) except where separately attributed
Cover art: painting by Kathleen Wallace, *Irrernte-arenye Singing*, 1997
Filmwork by Image Digital, Adelaide
Printed in Australia by Griffin Press, Adelaide

Foreword

Over the past decade, the Eastern Arrernte people at Keringke Arts have forged their own radiant style of painting, creating works of microscopic detail that teem with abundant life. Keringke artists at Santa Teresa (Ltyentye Apurte) use their innate love of pattern, vibrancy and shininess to celebrate their affinity with the land and its spiritual resonance. In opposition to the ochre canons that surround many forms of Aboriginal Art, opalescent colour sings with a cheeky intensity in the works made at Keringke Arts.

The art form that opened the way to this new form of artistic expression at Santa Teresa was textiles. Paralleling the intense interest in batik in the Central Australian communities of Ernabella and Utopia that developed through the 1970s and 1980s, lino-block printing and silk painting were introduced at Santa Teresa in 1987, nine years after the land had been returned to the Eastern Arrernte people. The process of cutting the lino blocks encouraged artists to experiment with linear pattern, while fabric painting engendered an interest in colour, thereby building on earlier lessons in drawing, painting and crafts at the mission.

Through rigorous quality control and disciplined practice, an impeccable silk-painting technique, equivalent to that of Ernabella batik, has gradually been established at Keringke Arts. Artists use silk designer dyes and gutta (a form of latex) to seal off areas of colour, resulting in jewellesque silks of gyrating colour. The synthetic dyes produce pure colours that retain their intensity in small areas and are not diluted or blurred through the processes of wax removal essential for batik production. The lines of gold gutta resist create raised subdivisions in a variegated, tessellated surface, and this is seen to great effect in the mesmerising detail and bright proliferation of colour in Kathleen Wallace's *Irrernte-arenye Singing*, 1997.

Keringke Arts also specialises in painting on ceramic bowls and vases, picture frames, chairs and tables, none of which are made in other Central Australian communities. These utterly distinctive handpainted objects made for use in a modern world are also statements about cultural resurgence. Eastern Arrernte stories and

designs from Santa Teresa and the surrounding country form an indelible part of the works themselves. As the artists testify in the pages of this book—and through their work—Eastern Arrernte country is rich in rock art, sacred sites and artefacts. The eternal laws and wisdoms of the artists' ancestors, latent during the mission days, have come boldly to the surface.

Keringke Arts has provided a positive source of energy and cultural pride in the community that belies the social problems that many Eastern Arrernte people still experience. In common with other Aboriginal people from Central Australia, the Eastern Arrernte have had to contend with the damage caused by dislocation from their traditional country, being taken away from their parents, missionisation and difficulties with alcohol. The artists' resilience and spirit in the face of contact with the dominant culture is ever present in their mellifluent artworks of country in mind.

Judith Ryan
Senior Curator, Aboriginal and Torres Strait Islander Art
National Gallery of Victoria, Melbourne

Contents

Acknowledgments

Keringke Arts collectively represents all the artists, coordinators and people who, over the years, have directly contributed to the development of its arts activity and its philosophies and business practices. While this book has been authored by a collective group of people, there are individuals whose contributions we would like to acknowledge. The first of these is Agnes Abbott, not only for her significant contribution to this book, but for all the work she did in the early years to make Keringke Arts strong. Secondly, we give special acknowledgment to Kathleen Wallace, who has guided and overseen the development of the whole story contained here, as well as the Keringke Arts enterprise for many years. Special thanks go to Therese Ryder for her work as the main researcher on this project, and for interviewing all the artists and translating their stories. We gratefully acknowledge the work of Josie Douglas at IAD Press in her role as editor and thank all the contributors to the book: Brother Ed Bennett, Miriam Dieudonne, Cait Wait, Liesl Rockchild, Myra Hayes, Gabriella Wallace, Jane Young, Bridgette Wallace, Mary Oliver, June Smith, Serena Hayes, Camilla Young, Marie Young, Jane Oliver, Bernadette Wallace, Sharon Williams and Tim Rollason. We also thank Judith Ryan for her foreword to the book. Lastly, we would like to thank our sponsors and the publisher for giving us the opportunity to have our story told and shared.

IAD Press would like to thank Marg Bowman for her invaluable assistance with this book. Our gratitude also to Mandy Paul and Jenny Green for kindly checking early drafts.

IAD Press also wish to acknowledge and thank the following for use of photographic material: National Archives of Australia for the photograph of the Bungalow [A263/3;6a] (page 4), Brother Groves for the photograph of Arltunga (page 6), Brother Ed Bennett for the photograph of the Little Flower Mission (page 5), and the Native Title Unit at the Central Land Council for the photograph of Myra Hayes (page 7).

The Keringke Arts Centre and IAD Press wish to thank the Australia Council and the Northern Territory Department of Arts and Museums for their assistance with the production of this book.

Always painting

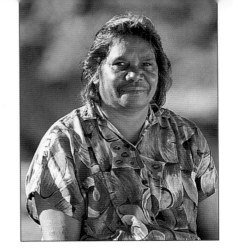

Like the women whose stories are told here, I regard myself as an artist first, but also work as a researcher, teacher and translator. In the middle of 1997, I started working on this book for Keringke Arts. I have collected stories from the artists who work there and from other people who have had a long association with the mission.

Stories were collected from the artists in a number of ways. I interviewed some in Arrernte and then transcribed the tapes in Arrernte before translating them into English. Some people spoke in English and the stories were written straight down that way. A few of the artists also wrote down their own stories in English. Where there were gaps in information, individual artists were interviewed again and this is how all the stories came together into the one final story. Agnes Abbott and Kathleen Wallace were called upon on many occasions to add information and in most of these sessions came out with more and more stories, some of which are recorded here.

As I currently live in Alice Springs, working on this book for Keringke Arts has allowed me to return to Santa Teresa, which is really good, as I always feel at home, it is so peaceful and quiet. I was born at Todd River Station and I grew up at Santa Teresa, where I also went to school. It is very different at Santa Teresa now from when I was growing up. During my younger days, when I was living in the girls' dormitory, painting didn't interest me. It was something I didn't know until I started school. At school we would do drawings on slates and on paper with charcoal, coloured pencils or crayons. Since the first time I held a brush in my hands, I have never let go of it. I am always painting.

There have been many changes around the mission. I have many memories about my school days and friends, some who have now passed on. The mission has grown steadily from almost nothing, and all the way through, people have kept their strong faith towards the Church. When I look back over the days, weeks and months of working on this book, I can see that the stories I have collected from the artists are going to make everyone feel very proud, proud that they have their own book. It is good because it will let everyone know about the beautiful work that comes out of Keringke Arts and will hopefully help in making it even stronger in the future.

Therese Ryder

Traditional homelands of the artists

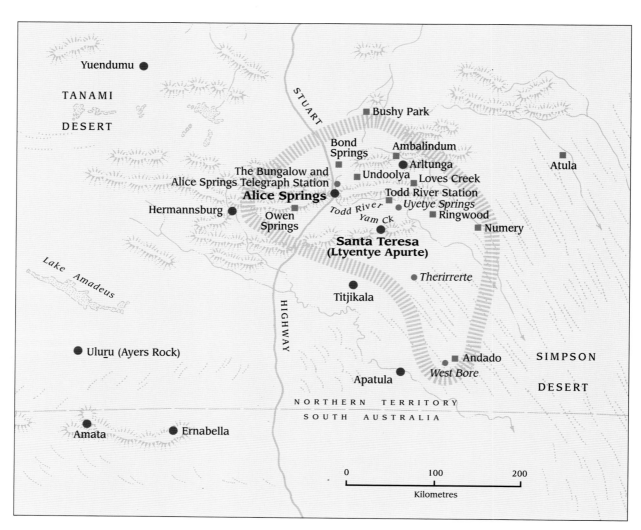

Yuendumu

TANAMI

DESERT

Bushy Park

Bond
Springs

Ambalindum

Arltunga

Atula

The Bungalow and
Alice Springs Telegraph Station

Undoolya

Loves Creek

Alice Springs

Todd River Station

Hermannsburg

Owen
Springs

Todd River

Uyetye Springs

Yam Ck

Ringwood

Numery

**Santa Teresa
(Ltyentye Apurte)**

Therirrerte

Titjikala

Uluṟu (Ayers Rock)

Andado

SIMPSON

Apatula

West Bore

DESERT

NORTHERN TERRITORY

SOUTH AUSTRALIA

Amata

Ernabella

Lake Amadeus

STUART

HIGHWAY

0 100 200

Kilometres

Area covered by this map

X

Santa Teresa: formation of a community

Santa Teresa is an Eastern Arrernte community of about five hundred people, located eighty kilometres south-east of Alice Springs. The country surrounding it is rich in rock art, artefacts and ceremonial sites. In Eastern Arrernte, Santa Teresa is called Ltyentye Apurte, which means 'stand of beefwood trees', and community members use both the English and the Eastern Arrernte name interchangeably. Santa Teresa is a community noted not only for its cohesion but also for the nature and variety of its support services and recreation facilities. Along with the Keringke Arts Centre, the Community Education Centre and Adult Education Centre, other facilities include a spirituality centre, a women's centre and the community club. Although Santa Teresa was started as a Catholic mission in 1953, the people living at Santa Teresa, including the artists whose stories are presented here, remain strong in their language and culture. They also maintain a strong Christian faith, and to this day the Church remains a focal point in the community.

People living at Santa Teresa have traditional homelands that extend out from the community on all sides. A person's father's country is special to them, but other places from their mother's side are also important. The

Detail of plate 11

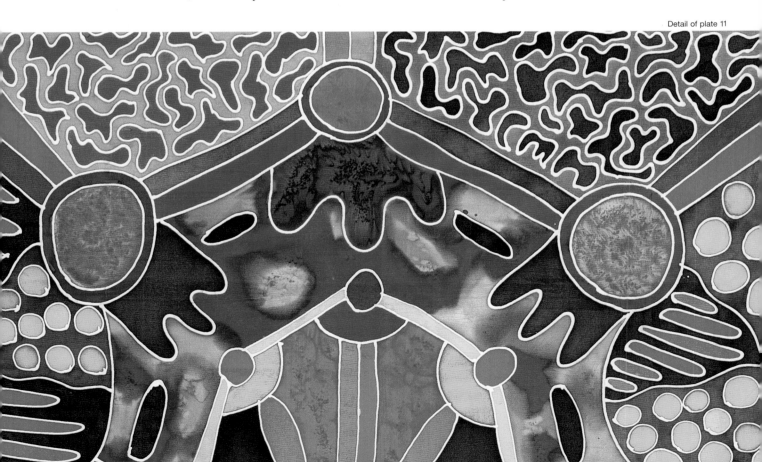

women from Keringke Arts can trace their families in many directions: to Hermannsburg in the west; to Bushy Park, off the Plenty Highway, to the north; to West Bore, just south-west of Andado Station, near the South Australian border; and, in the east, to Numery Station and then further north to the east of Atula Station (now called Apiwentye), which is towards the Queensland border. Family connections also extend to the south: through to Apatula, Titjikala, Ernabella and Amata. People living at Santa Teresa also maintain strong connections to family in the town camps and residential pockets of Alice Springs, as well as smaller communities and outstations scattered throughout Central Australia. Connections to sacred sites, Dreaming places and food sources still draw people to many corners of their traditional land.

Today, as they did before European settlement, people living at Santa Teresa are generally able to travel throughout their traditional country and do so on a regular basis. However, many traditional owners have difficulty accessing their traditional country, as much of the land is on pastoral leases. A lack of care and understanding has often led to cattle and four-wheel drive vehicles causing immense damage to significant places. Despite this, elders continue their ongoing struggle to have the land that they were born on and grew up on maintained and respected.

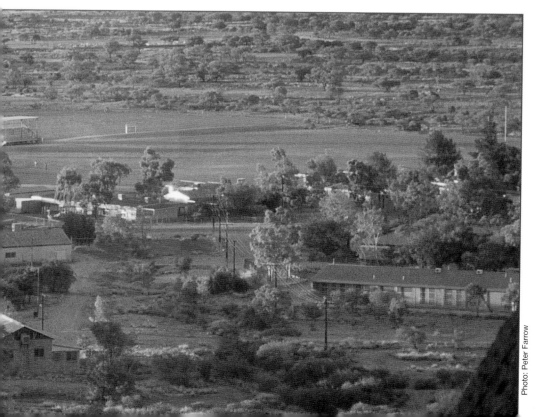

Santa Teresa community

Early contact history in Central Australia

Traditionally the Mparntwe (Alice Springs) area has had an important ceremonial focus and has drawn many Arrernte people from surrounding regions. Eastern Arrernte people have a natural link to the township of Alice Springs built on these pre-existing cultural ties. The history of European settlement in Alice Springs and the role of the Catholic Church have had a huge impact on Eastern Arrernte people, and one of the outcomes of this was the eventual establishment of Santa Teresa.

In 1860 John McDouall Stuart became the first European to explore land to the north of South Australia. He reported that Central Australia was rich pastoral country and in 1863 the South Australian Government annexed the Northern Territory. Stuart's early exploration paved the way for the establishment of the Overland Telegraph Line, which was to link Darwin with Adelaide and open up communication between Australia and the rest of the world.

The Alice Springs Telegraph Station was completed between 1870 and 1872 and became the focal point of European settlement in Central Australia. Not long afterwards the first pastoral lease was established at Undoolya Station, followed by stations at Owen Springs and Bond Springs, and Alice Springs soon became the legal, medical and administrative centre for the region. The spread of permanent European settlement and the introduction of large numbers of cattle onto Arrernte land diminished traditional food and water resources and saw the desecration of many sacred sites. Arrernte people resisted encroachment onto their lands by killing cattle and carrying out sporadic raids on stations. The reprisals meted out by pastoralists and police frequently took the form of indiscriminate shootings and massacres, many of which went unrecorded in official documents.

Although protracted conflict did occur between Aboriginal people and pastoralists throughout Central Australia, a certain degree of cooperation developed between the two groups. Aboriginal people were drawn into Alice Springs and surrounding stations for food, clothing and work. Many Eastern Arrernte people found work on pastoral stations as domestic servants and stock workers. Eastern Arrernte people visited

Alice Springs on holidays from stock work and to collect rations. The telegraph station became the central point for the distribution of rations and many Eastern Arrernte people camped around it. For Arrernte people Alice Springs became the centre for economic exchange.

The *Aboriginals Ordinance 1911* was passed to regulate interaction between European and Aboriginal people as the growing population of 'half-caste' children became an increasing concern to authorities. The Protector of Aborigines was given power to enforce the Act and had extensive control over many aspects of Aboriginal people's lives. During 1914–15, a compound for children of mixed descent, known as the Bungalow, was established in the town and many children were forcibly removed from their mothers and placed there. When the telegraph station was closed in 1932, the area was proclaimed an Aboriginal reserve and the Bungalow, which had been temporarily relocated to Jay Creek, was moved there. It was administered by the Department of Native Affairs as a home and school for 'half-caste' Aboriginal children.

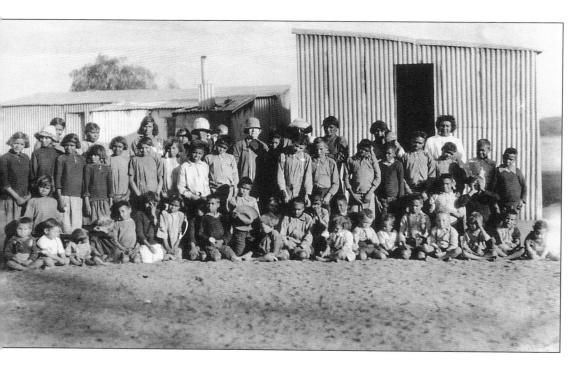

Children at the Bungalow, Alice Springs, 1928

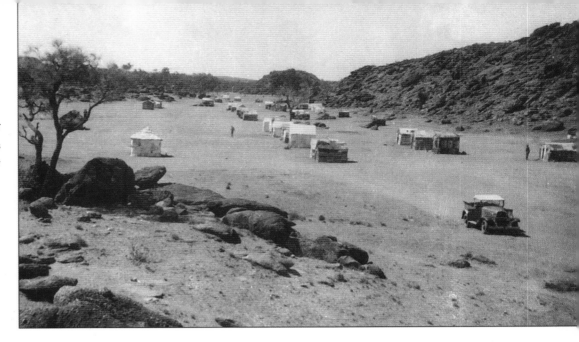

The Little Flower Mission at Charles Creek, 1937

The Little Flower Mission and World War II

The first Catholic church in Alice Springs was started in 1929 by Father James Long. In 1935 Father Patrick Moloney succeeded Father Long and concentrated on establishing a mission for Aboriginal people. Brother Ed Bennett, a long serving Marist Brother at Santa Teresa, remembers that 'the mission started in the backyard of the presbytery and catered for children and later for adults...As the numbers increased, facilities at the presbytery became inadequate.' There was also considerable opposition to the presence of Aboriginal people at the church from Alice Springs parishioners.

In 1936 the Bungalow reserve was expanded to include the area of Charles Creek and the Catholic Church moved there. The mission attracted many Arrernte people. It became known as the Little Flower Mission, named after Saint Thérèse of Lisieux, a Carmelite nun who called herself a 'little flower' and spread the message that small acts of charity and devotion were important.

The Second World War came to Central Australia on 19 February 1942 when Darwin was bombed and Alice Springs became the logistical centre for the northern battlefield. Thousands of Australian and American soldiers encamped in and around Alice Springs and strict curfew regulations were enforced on the population. Wartime conditions and the influx of military personnel led authorities to recommend that the Little Flower Mission be moved out of the town area. Arltunga, one hundred and fifteen kilometres north-east of Alice Springs, was seen as the most suitable site for the relocation of the mission.

Relocation to Arltunga

An army convoy moved the Little Flower Mission to Arltunga in 1942. Brother Ed Bennett remembers: 'It was a very pretty place, Arltunga, surrounded by hills. It was once a gold mining settlement. The only great worry was the water supply, which was the cause, later on, of another site being chosen.' The Crown granted the Catholic Church a block eighty kilometres south-east of Alice Springs and in 1953 the mission was moved there, becoming known as the Santa Teresa Mission. The first building at Santa Teresa was an old army hut which had been brought down from Darwin and erected by missionaries and the people at Santa Teresa. A close relationship developed between the mission and surrounding pastoral stations such as Andado, Atnarpa, Yambah, Bond Springs and Deep Well.

Myra Hayes, an Eastern Arrernte elder, can remember clearly the very early days of the Catholic Church at Charles Creek and its subsequent move to Arltunga and then to Santa Teresa. Myra's family lived at Santa Teresa before moving to Amoonguna and then to Whitegate, a town camp which is on the eastern side of Alice Springs. During Myra's younger days she worked on various stations—at Undoolya Station for old Mrs Hayes and at Deep Well Station for Billy

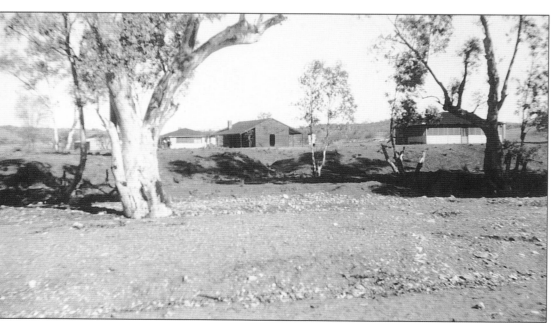

Early days at Arltunga, 1943

and Jan Hayes—and in later years was a health worker for the Department of Health at Amoonguna. She has also made an invaluable contribution to a number of native title land claims through her work for the Central Land Council.

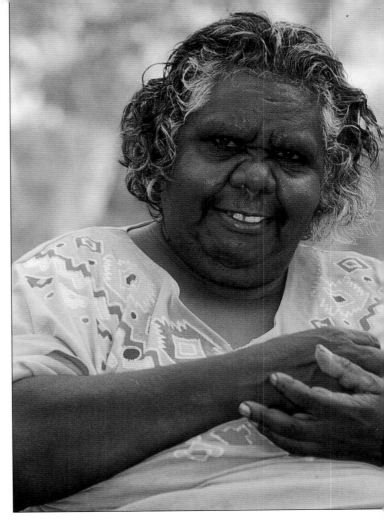

Myra Hayes

My name is Myra Hayes and I was born at Undoolya Station. That was when my father was working there doing stock work. We lived there a while, and would go in to town to where the first Catholic group started up at Charles Creek. We would stay there from time to time and then go back out to Undoolya Station again.

Sometimes my father and the other men would come in to town to get rations. There were some of our old people who used to work in town, when the town had just a few houses. My grandfather worked for some of the first white people who were there. He did some gardening.

We had moved back to Undoolya. It was at that time that the first Catholic group from Charles Creek was being moved away to Arltunga. The war had come. They were moved by a convoy of army trucks. The priest, the brothers, Father Moloney and Brother Groves were the first mob with the first Aboriginal Catholic group. They all got shifted to Arltunga, and then my family moved there too.

We all lived at Arltunga for some years. Then we started having problems with the water that the people were drinking. A lot of people started to get sick, even the babies. Some of the kids didn't survive after drinking the water. The flying doctor went there just about every day for the people and the little babies. I had my two aunties there, one of them also passed on, she got buried there at Arltunga. Some years later, Bishop O'Loughlin was now talking about moving the mission to Santa Teresa. The dormitory was put up, and one of the first houses was made from some of the old sheds that were shifted away from Arltunga. Today the people are all there at Santa Teresa now.

The land is returned

After being on the mission for years, and also working there, there came a time when traditional homelands were being given back to Aboriginal people, so my family all moved back to town, to Amoonguna. My father got our land back at Mt Undoolya. Then the family all moved back and stayed there. That was until sometime in the eighties, when there was a big car accident. Some of my family was involved in it, so after that happened, I moved away from Mt Undoolya and went back to Amoonguna. Myra Hayes

The *Aboriginal Land Rights (Northern Territory) Act 1976* had a great impact on Aboriginal rights in the Northern Territory. With the advent of the Land Rights Act, most of the existing Aboriginal reserves became Aboriginal land, with inalienable freehold title held by Aboriginal land trusts, and a procedure was established for claiming unalienated Crown land and Aboriginal-owned pastoral leases. In 1978 Eastern Arrernte people were presented with title to the land at Santa Teresa. By 1983 the mission had passed control of its facilities to an elected Aboriginal council and Santa Teresa had developed into a small township.

Evolution of the Keringke style

Before the white man, people used to do drawing on sand, tell stories on sand with songs. That's how we learned, through stories and songs, to draw. I remember my grandfather used to teach me to draw on sand by telling stories and songs. He used to take me out, and some of my other relations, to show us the drawings in caves and tell us stories about them. That's how I learnt to draw.

Kathleen Wallace

The story of Keringke Arts is one story but also many stories. It details the development of an energetic art centre and the evolution of a modern artistic style, but likewise, it is a collection of individual life stories from a succession of Eastern Arrernte women. The Eastern Arrernte people at Santa Teresa take enormous pride in their culture and in their community. It is this inner pride and the positive energy it generates that motivates the community in all its achievements, and this is no more apparent than in the artworks created at Keringke Arts. While on first glance it is the bright colours and intricate designs which give the Keringke art its dynamic vibrancy, its unique appeal lies in the energy which rests below the surface of each work.

Storytelling plays an important role in the artwork of the senior artists at Keringke Arts: Kathleen Wallace and Agnes Abbott can

Detail of plate 20

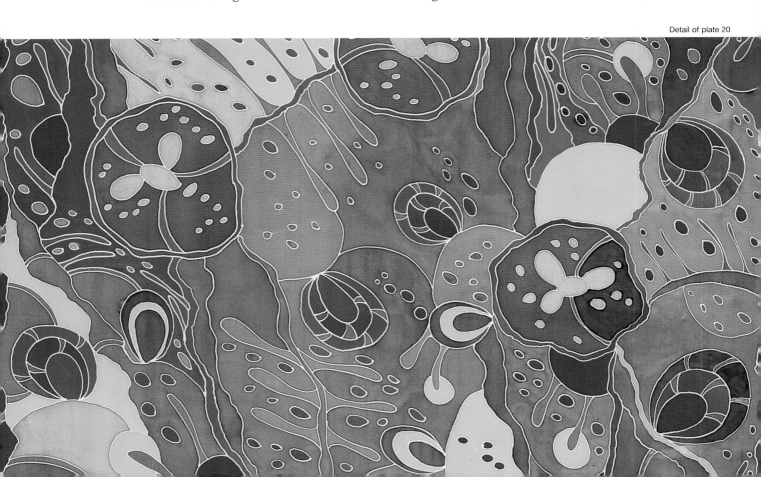

remember the old ways and their paintings are narrations about creation stories, about country and about ancestors. These stories are painted and imparted as living histories in which the women are themselves a part, where ancestors and country are all-encompassing in their lives. The paintings by the younger women, who form the majority of artists now working at Keringke Arts, are a reflection of their contemporary lifestyle and a personal expression of their culture.

In the early years the work at Keringke Arts encompassed a range of artistic styles, a mixture of pictorial landscape painting and traditional symbolism associated with Dreamtime stories. Depictions of local foods such as bush bananas, witchetty grubs and honeyants often appeared in these paintings, usually within a field of symbolic pattern and colour. Today, the 'Keringke style' is recognised for its intricate symbolism and rich colours, its extremely fine patterning and complex design structure. Each artist continues to develop her own personal pictorial language and symbolism, with work often becoming highly abstract in composition, but always retaining the basic dotting style.

Keringke Arts has developed a distinct reputation for its works of art on silk. Painting on silk was introduced in the very early days of the art centre and has continued to be a main focus. From the beginning, the women were attracted to the use of bright colours. As the skill and practice of silk painting developed, the simple designs in the early works

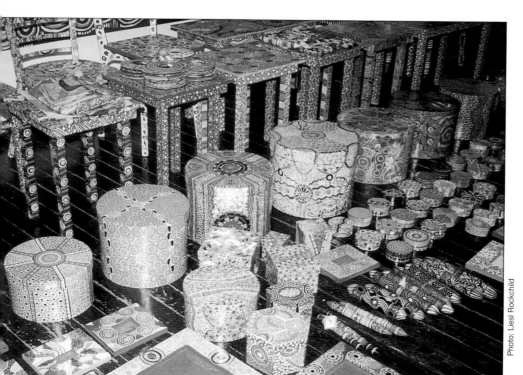

Left: Decorative gifts and homewares ready for the *Telling Our Story* exhibition at the Rainbow Serpent Gallery in Sydney, 1996

Right: The individual styles of three Keringke artists, Marie Young, Kathleen Wallace and Sharon Williams, are reflected in these painted vases

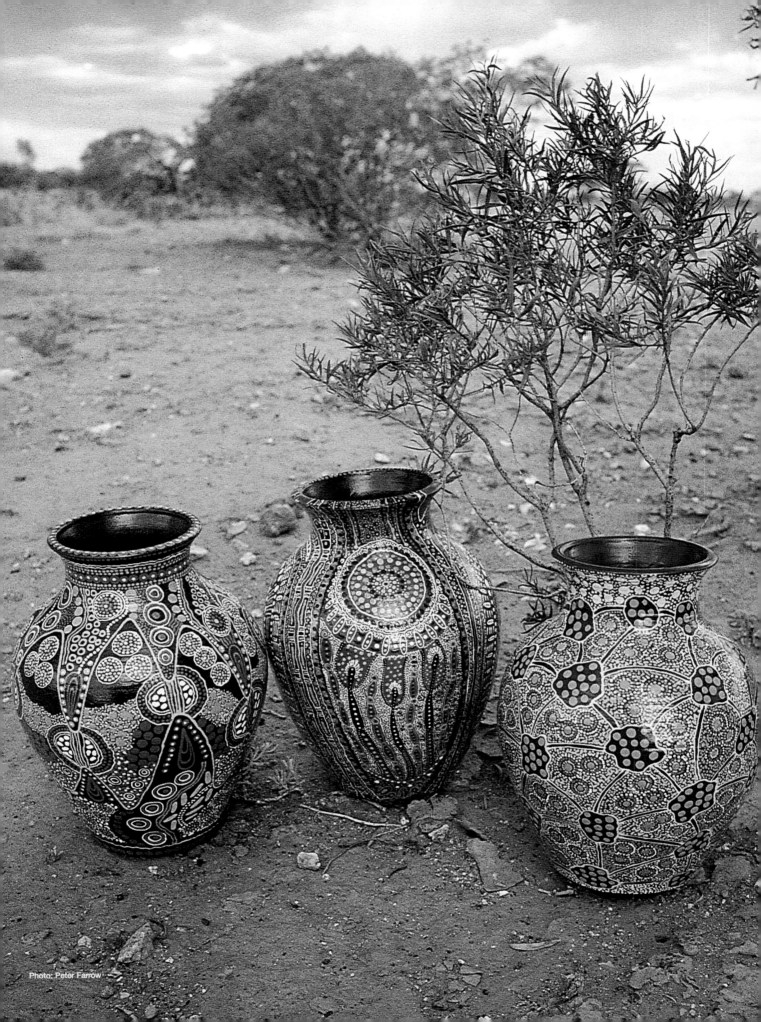

have evolved to highly elaborate ones, with artists' colour combinations becoming brighter and richer over the years. Designs are outlined in gold, copper or white and filled with iridescent colours such as turquoise, aqua, gold and purple. Frequent use of almost mirror image compositions gives the designs a powerful visual strength. Painting on silk allows for a luminosity not available in other mediums, for the material itself has a luxurious surface texture which allows the strong, gleaming colours of the silk dyes to shine through.

Increasingly Keringke artists have begun to translate their designs on to paper and other surfaces such as terracotta, desert oak and wood. While the design style and use of colour remain the same on the different surfaces used at Keringke Arts, each new medium shows the skill and versatility of the artists.

Early Santa Teresa art and crafts

I remember using chalk on slates and also drawing with coloured pencils. There were girls and boys who were very good at drawing. During that time, I didn't know about painting or even using paints and brushes. In school, one of the nuns, Sister Anastasia, introduced paints and brushes to us...Other artists visited Santa Teresa, like Mr Sawjack, who came from Europe as a travelling artist. He did oil paintings and also portraits. Dr Ethel Robinson was another artist, she would take an afternoon off and take me and Therese Ryder for painting lessons, painting hills and trees.

Gabriella Wallace

Examples of the early craft work at Santa Teresa

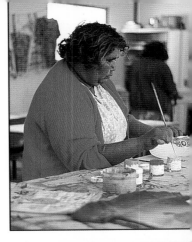

Art and craft practice—that is, western art and craft practice—was first introduced into the community in the late 1950s through the activities of the mission school and the Sisters of the Sacred Heart who taught there. According to Kathleen Wallace, 'When we were in the dormitory, we used to do a lot of knitting, sewing on small clothes and embroidery. We used to make dolls and dolls dresses. Our mothers and sometimes the nuns used to teach us how to make little rag dolls. Small wire toys were made too, little horses and cattle, windmills and little wire trolleys.' The students were encouraged to draw, using coloured pencils, crayons and charcoal on paper and slates, and Sister Anastasia also introduced paints and brushes. When visiting artists came to stay on the community, children would often follow them around watching how they painted the surrounding landscape.

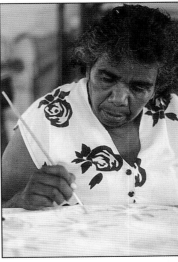

The first official teacher of art and craft at the mission was Sister Edith, who taught at the school in a specially designed art and craft room. Sister Edith arrived in 1974 and started teaching pottery, copperwork, macrame and screen-printing to adults, with some of the men learning leatherwork. As Kathleen Wallace recalls, 'The men used to make their own leather. It was made in the old canteen area. The men used to go out and kill the bullocks and bring back the hide. Then they would soak it in water with acid and leave it in there for a month or so. When they pulled it out and dried it, it was leather. Then they'd make bridles for the horses, and hobbles. Only the men used to do this, especially the Wallace men. They were the stockmen.' In 1975 a teacher at the school, Miriam Dieudonne, took over from Sister Edith.

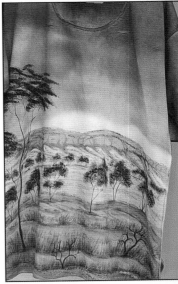

When Miriam became the community's adult educator in 1981, she continued to run courses in art and craft. She designed a training

Top to bottom: Jane Young painting on a T-shirt;
Bessie Oliver at work on a silk; Handpainted T-shirt;
June Smith works on one of the very early Keringke silks

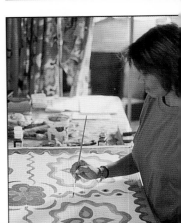

Painted wooden bangles

course that ran for a year, incorporating most of the art and craft activities that were happening in the community at the time, and she continued the work with sewing, leather, copper, pewter, jewellery-making and pottery. 'We had some visiting potters come in and run short courses and there was a small amount of money for part-time instructors to run short courses,' Miriam recalls. 'We also heard about some batik work being done at Ernabella and everyone started to get excited about doing batik. Some batik workshops were undertaken with people from different camps.'

Unlike other communities where people were keen to paint their Dreaming stories, people at Santa Teresa were very hesitant about this. As Miriam recalls, 'I think people were a bit frightened to put down their own paintings or country stories on paper, and nobody wanted to put down any dots at all. The men were very strong and even if someone did a few lines, they would have to be careful that the old people had seen it and said it was okay.' Kathleen Wallace remembers

Artists at work in the old dining room prior to the art centre being built

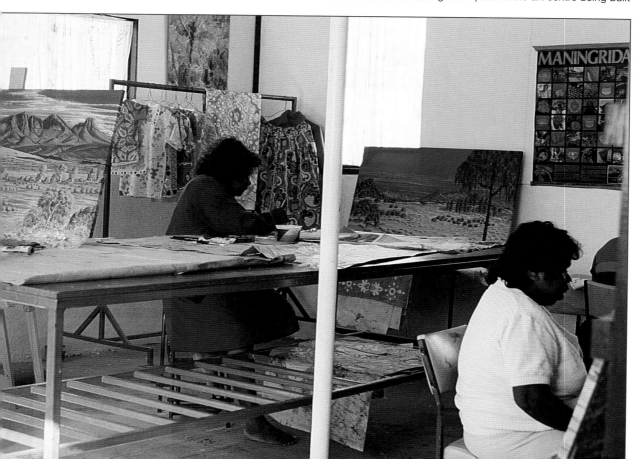

that in the early days 'old people used to be really strict, even if we wanted to put our stories down of papers. We were only allowed to do designs which didn't mean anything.'

The first artistic style to gain recognition from Santa Teresa was the early watercolour landscapes, referred to as paintings done in the 'Namatjira style'. The artists at Santa Teresa developed their watercolour style quite independently of the watercolourists who were painting at Hermannsburg. Kathleen Wallace remembers, 'I used to admire Namatjira's work. When I looked around here, my country was different than his. He had really bright coloured painting. When I started doing my painting, I looked around. My country was different, different colours.'

While Miriam was in the art and craft room, she tried to get people to do paintings and sell them. She set up a showroom in the adult education room so that everything was on display for visitors to buy. 'It was very slow, and there wasn't much money involved, but it was the start of an enterprise anyway,' Miriam recounts.

Watercolour landscape by Gabriella Wallace reminiscent of the early 'Namatjira style'

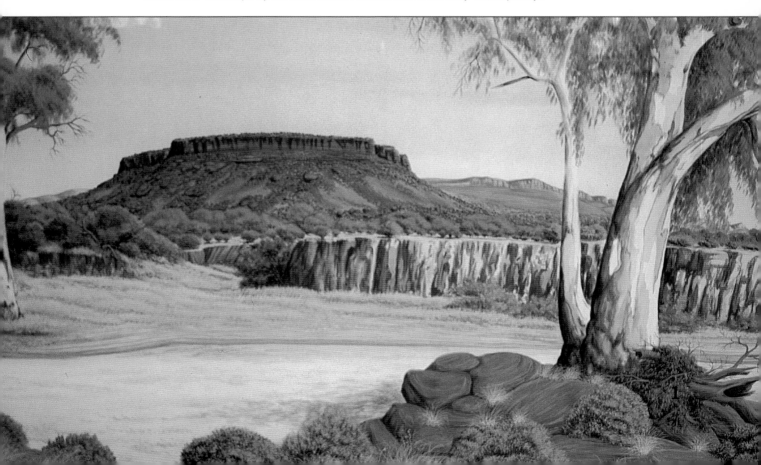

The Keringke Arts Centre

In 1987 the Northern Territory Open College provided funding for a nine week fabric-painting course. The teacher appointed was Cait Wait and her arrival signalled a turning point for the artists at Santa Teresa, with new techniques introduced for lino-block printing and silk painting. What started as a short course turned into a five year commitment for Cait Wait, and the start of what was to become Keringke Arts.

In those nine weeks, I worked mainly with the women who were training to be teachers. There were about twelve to fifteen women at the time, and we began learning colour theory, lino-block carving and printing, and printing and handpainting on T-shirts, simple garments and tablecloths. The women's confidence to draw, make pictures or conquer blank space was very limited when I arrived. They were extremely shy. I thought that the lino-block carving would offer a medium they would find instinctively comfortable, for they first had to physically carve the lino before making images from it.

Left to right: Fay Oliver, Cait Wait, Therese Ronson, Kathleen Wallace with Denise Doolan, Mary Oliver and Marie Therese Ryder with work for the 1988 Australian Bicentennial Craft Show

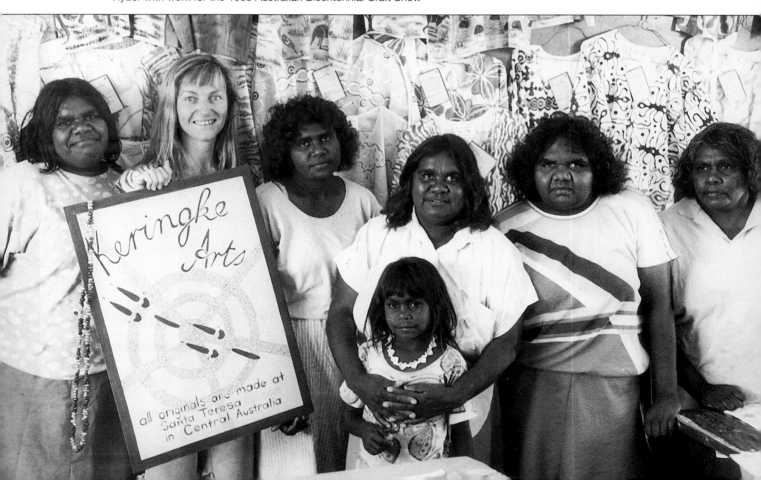

The Keringke artists take in the sights of Sydney, 1988

Traditionally, the women would have carved wooden items, and so I felt this might help them make some cultural connections. The transformation process was also very important. The transformation from the lino block to the printed image, where the colour magically filled in the blank spaces, brought the carved image into another dimension. As this process was repeated, with each print being placed next to each other on a piece of fabric or paper, space was conquered, and the confidence of the women began to grow.

Cait Wait

Due to the success of the initial course, it was extended by an extra six weeks, in which time there were many discussions, meetings and bush trips amongst a constantly changing and evolving group of women. A committee was established and a training scheme developed so that the project was eligible for funding from the Department of Education, Employment and Training. At the same time the process of being incorporated commenced. Artwork and garments generated through the project were sold locally in the community and in Alice Springs. As the work from Santa Teresa began to be recognised around the Alice Springs region, the women started trading under the banner of 'Santa Teresa Designs', and the 'Santa Teresa style' became synonymous with Eastern Arrernte culture.

In 1988 the women exhibited their work at the Australian Bicentennial Craft Show, and were the first Aboriginal group to do so. They went to the craft show again in 1989, and in 1990 began to consolidate their range of 'marketable' goods, painting on objects and useful items, while also continuing the silk painting and T-shirt designs.

The success of a funding submission to the Aboriginal and Torres Strait Islander Commission (ATSIC) in 1988 enabled a new purpose-built art centre to be constructed, with the artists having an active involvement in its design. The Keringke Arts Centre opened in early

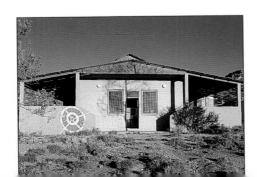

The newly completed
Keringke Arts Centre

Keringke artists with
their hosts at Ohakune,
New Zealand

1989 and over the next few years, as the Keringke Arts enterprise began to grow, it became a prototype for other emerging art centres in the region and provided the impetus for many positive exchange visits from other communities. A cultural exchange program with Maori artists took the Keringke artists to New Zealand, where they presented a solo exhibition at the Te Taumata Gallery in Auckland in 1992.

Growth of the art centre

The relationship between each coordinator and the artists has been positive and congenial, with the great rapport between the artists themselves enriching the continued growth of the art centre. In 1993 Liesl Rockchild became the new coordinator, replacing Cait Wait and Kate Monger; Kate had been coordinator for a brief time after Cait Wait left. The women began to expand the Keringke Arts product range significantly. While the previous five years had seen designs become stronger and their overall colourful style emerge, with Liesl Rockchild came a strengthening process and a focus on producing works of a high quality finish. Very systematic in her approach, Liesl prioritised quality customer service and set about establishing a high standard of professionalism in all areas of the business. From this practice came an atmosphere of commitment and enhanced pride, an outcome which proved successful in the marketplace.

Left to right: Liesl
Rockchild, Jane
Oliver, Camilla Young,
Kathleen Wallace,
Mary Mulladad, Marie
Young, Therese Davis
and Mary Oliver pose
for a Christmas photo

The artists had already developed a history of painting on everyday objects such as hand-held mirrors and balsawood boxes and extended this activity to include homeware and giftware items. Amongst the items painted were chairs, tables, ceramic vases and bowls, photo frames, giftboxes and mirrors. Paintings on canvas and paper also continued, with the artists focussing on derivations of traditional symbolism rather than representational imagery.

Handpainted T-shirts gradually disappeared from the Keringke range as artists directed their design strength and vitality to silk paintings. Lengths of handpainted silk, from two to five metres, became more

prominent and markets for the artists' work continued to expand throughout Australia and overseas. Works by artists were reproduced on cards and giftwrap and in diaries and on calendars. In 1996 a Keringke Arts design was licensed to be reproduced on commercially printed fabric. The production of artworks and the number of artists, exhibitions, retail outlets and sales continued to grow along with Keringke Arts' reputation. The art centre was also successful in obtaining funding for the position of an Aboriginal trainee office manager. The position was funded so that Keringke Arts could move towards being completely operated by Eastern Arrernte people.

In the mid 1990s Keringke Arts faced a time of funding uncertainty. At that time many art centres lost their funding or received massive funding cuts. Keringke Arts managed to survive this time of hardship and, along with other art centres in Central Australia, took part in a successful political campaign to ensure funding was retained. Keringke Arts is typical of art centres in the region in that it is a very important part of the social, cultural and economic fabric of its community. Aboriginal art is one of the most viable ways Aboriginal people can attain economic independence and achieve control over health, education and housing.

Jane Young and Liesl Rockchild at a protest rally against funding cuts to Aboriginal art centres, 1995

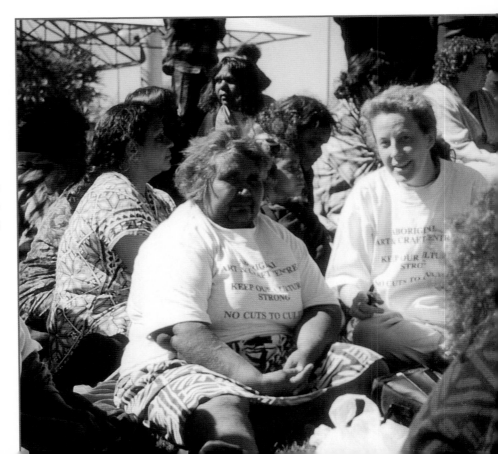

New directions

Looking for a new coordinator was a big decision. All the women expected to have a woman, but we had a man apply as well. Camilla Young/Kathleen Wallace

In 1997 Keringke Arts broke with tradition and appointed a male coordinator. Tim Rollason brought with him experience in cultural and enterprise development. Camilla Young and art studio manager Kathleen Wallace remember that it was 'a big job to go through the applications. We interviewed people over the phone first, but couldn't decide, so then we interviewed them in person. After that we decided Tim was the best because of his experience with Aboriginal art.'

During 1997 and 1998 the Keringke Arts program of solo exhibitions increased rapidly, with shows in Sydney, Alice Springs and Darwin. Markets for their work also began to expand internationally in countries such as Belgium, Holland and France. Works on paper started to become the focus in these displays, with the first exhibition of the artists' paintings on canvas presented in Sydney in August 1998. A project involving Australian designer and artist Linda Jackson also saw the release of a range of screen-printed fabrics designed by artists Kathleen Wallace and Marie Young.

As Keringke Arts continues to grow and expand, a move towards the fine art market is emerging, with more and more designs being applied to works on paper and canvas. The continual development in the strength of these works is testament to the years of commitment by the artists, reflecting their cultural pride and artistic identity within the Australian and worldwide community.

Keeping and teaching culture

Agnes Abbott (nee Bloomfield) is a traditional owner of the Santa Teresa area. Ltyentye Apurte is her mother's Dreaming place and Santa Teresa is her grandfather's country. Agnes is a strong and respected elder of the Ltyentye Apurte community and the wider Arrernte community. She is a key authority on Eastern Arrernte culture, having a vast knowledge of the Dreaming stories associated with her country. Agnes was a driving force in the establishment of Keringke Arts. In the first three years of the art centre, Agnes was there every day, painting and making it a strong place. Creating the art centre gave Agnes a medium to pass on her knowledge of country to other women in the community. Agnes was the first woman to paint stories about her country, which then developed into many actual visits to traditional country. This reconnection with country began a process which saw a strengthening and revitalising of culture within the community.

Throughout her adult life, Agnes Abbott has worked closely with organisations such as the Aboriginal Areas Protection Authority and the Central Land Council to map out her country and record its associated stories, ensuring that sacred sites are listed and protected. As a member of the Ltyentye Apurte Community Government Council for over twenty

Detail of plate 6

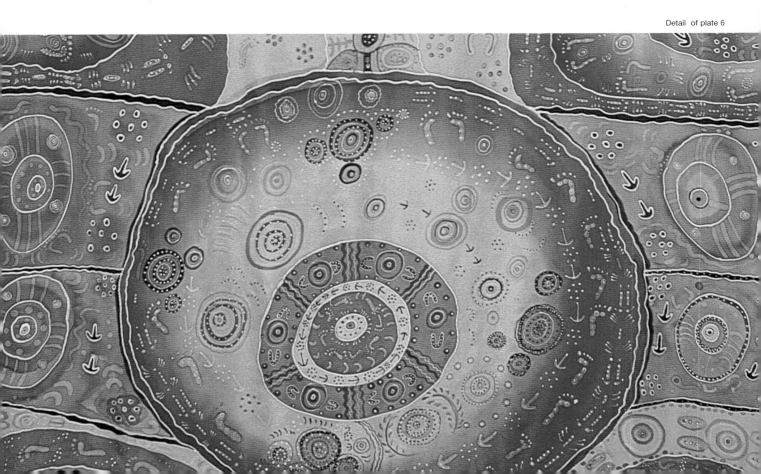

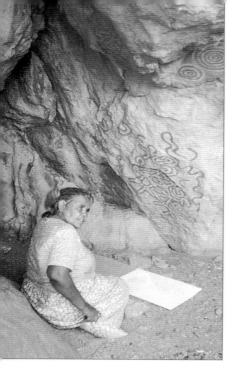

Agnes Abbott at Inannge showing paintings of the Atyelpe Dreaming story

years, Agnes has played a pivotal role in the positive development and shaping of Santa Teresa. After the art centre was up and running, Agnes then set about establishing the Santa Teresa Women's Centre. It was also through her efforts that Santa Teresa was made a dry community.

I'm Agnes Abbott. I was born at Loves Creek Station. My grandfather and also my mother lived at Loves Creek. Some of my family worked there while my grandfather looked after goats. He used to get water from the well and fill up the trough to water the goats. A lot of my family used to live around Loves Creek, and would move around from place to place...places like Todd River Station, Undoolya Station, Atnarpa Station and Uyetye Springs. That's where I grew up with my family.

When we were living at Uyetye Springs, my uncle heard there was a school at Arltunga, so my auntie and uncle took me, my cousin-brother and some other kids there to go to school. We travelled there on camels. I lived there in the dormitory for about a year and a half. We came back to Uyetye Springs for the Christmas holidays, again travelling on camels. We came back through Ross River, mainly travelling at night because of the heat. I was travelling with my mum's brother, Mrs Wallace's grandfather. From Uyetye Springs, we went to Todd River Downs looking for dingoes. People used to scalp the dingoes and sell the fur. I used to like travelling around, just walking around.

At Todd River Station there was one old white fella. His name was Eugene Neck. He wanted us to work around the station with boys and girls together. We'd saddle up our horses and go out and muster cattle, and he'd get our meal ready for when we got back. We'd all take turns at keeping watch on the cattle and to water them.

Then one day my sister asked me to go with her to Undoolya Station. I'd lived with my family and had only known them and not other people from Undoolya when I was asked to go. We got a ride with old Eugene Neck in one of those funny old cars. Off we went to Undoolya Station. When we got there, we got off the car and I was surprised to see there were a lot of people there. Soon I got to know them. They were some of my people, Arrernte people. They had a camp on the eastern side of Undoolya Station.

A lot of the old people were there, women and children.

When I was at Undoolya Station, my auntie asked me if I could work with her, so I said yes. Then after that I was working at the station. I had a job of getting up early in the morning, before six o'clock, to go out and milk the cows, and my auntie worked in the kitchen. After milking the cows, I used to take the milk back to the house, and sometimes we were taught to make some butter. We'd work till late evening, then we would walk home to camp. All that time I was working, I was never paid any money, only in rations.

After working at Undoolya for a while, I went back out to Todd River Station, where we would go to places like Santa Teresa. At that time, Santa Teresa was being built. The mission was just starting to move from Arltunga to Santa Teresa.

We used to travel around on camels. We were happy to learn a lot of things, like hunting, how to look for bushtucker, and tracking goannas, kangaroo and other food. At Santa Teresa we used to go and look for yams at Yam Creek. Keringke Rockhole was the main place for water during the times we were travelling. The old people would make camp just at the entrance of the gorge, make a big camp there. When we needed some flour, sugar or tea, the men would go in to town to get them. It took a week, maybe, because they were travelling on camels.

Some time after that, I went in to town, to see the races. Race meetings were held at the old racecourse area. One day at the racecourse, I met a man called Arnold Abbott, who was to become my husband. Since this time, we have been living together always. We had one daughter, Janey, and after she was born, we went back to Todd River. When she was a baby, we used to travel around Santa Teresa way, riding on a camel and walking. We used to camp at Anthony Waterhole, which is between the community and the orchard at Santa Teresa.

For a while, my husband and I lived at Granite Downs, west of Oodnadatta. We used to cut posts and make fences. I also worked at Oodnadatta in the store, and my husband worked on the railway. From there we came back to Alice Springs by train. We stayed in Alice Springs for a little while and then went back to Todd River Station. My whole

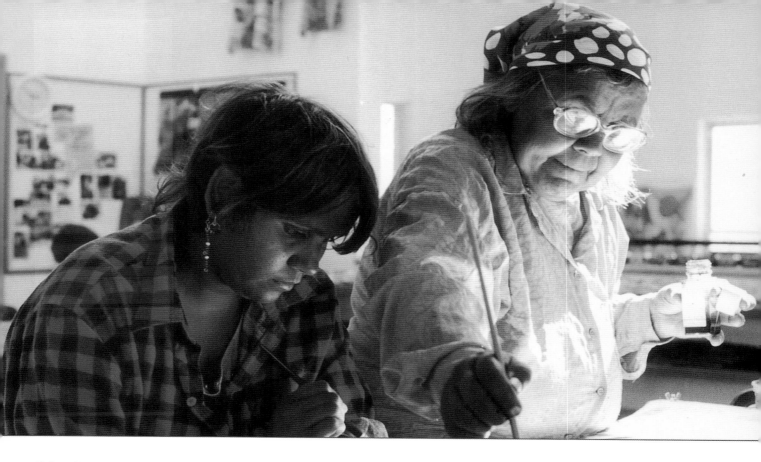

Colleen Young working under the guidance of Agnes Abbott

family was there. My grandmother, grandfather, uncles and all the relations. Mrs Wallace was there. She was a little girl then.

We all heard that the mission was moving from Arltunga to Santa Teresa and that there would be a school there. Other buildings, like the church, convent and presbytery were built before the people were moved to Santa Teresa. Some people travelled by foot with the nanny goats. Some of the ladies who were moving to Santa Teresa took a payment of rations over to my grandfather at Todd River Station. This was because Santa Teresa was his country.

My daughter was old enough to go to school. We moved to Santa Teresa, where Janey was put into school. She lived in the dormitory with a lot of other girls. The girls lived separately in a dormitory, and the boys, they were in another dormitory. The girls' dormitory was where the spirituality centre is now, and the boys' dormitory was where the old stone building is now, next to the club. I started work on the mission, helping the nuns to do their washing and kitchen work. They had lots of goats and sheep there. We used to cook up soup for all the people in the community. We'd chop up all the vegetables and cook it up in two half 44 gallon drums. At about three o'clock every Tuesday and Saturday,

we'd ring a bell for everyone to come up and get some soup to take back to their camp. A lot of old people were living there. We used to have a big vegetable garden. Brother Bush used to have a lot of young people helping him grow the vegetables.

People on the mission used to go out and cut rocks to build their own stone houses. They would go out, dig rocks and cut them, and put them in a heap so that the truck could go out and bring them back to the mission. There were builders who would build the houses for people. I had one, my own, with two bedrooms, a kitchen and verandah. When they built them, they'd collect clay, yellow clay, to mix with the cement, and then build the house. It was really hard work. We'd dig out the rocks with crowbars. My husband and I dug up the rocks for our house ourselves. We'd walk out there and take our lunch with us. We'd work all day and come back at night. Back then, all the people used to live where the old village is now.

There was this one nun, Sister Anthony Mary, who got us to work, to learn sewing. We would use one of the rooms at the old hospital. The old hospital building was where Keringke Arts Centre is now built. There we learnt sewing, to make kids clothes, smocking, and some fancywork

Agnes Abbott telling the Keringke story at the Keringke Rockhole

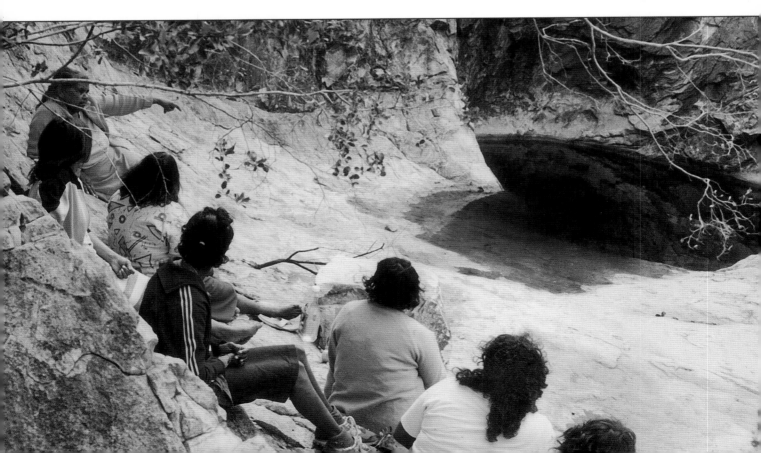

on tea towels. I was one of the women on the mission who was sewing uniforms for school, and doing other fancywork for the Alice Springs Show. I kept on working for the mission, and was now teaching younger women to sew, and some older women.

Sister de Chantel was the school principal and there was a room for some ladies to do sewing. I was one of them. We did sewing on some baby clothes and some clothes for bigger kids. There was also a school craft centre in the school yard. A few of the other women worked there learning to do pottery with two or three men. Sister Edith worked there, and soon after that, Miriam, who was to teach at school, arrived. After a while she joined in at the craft centre and was working there.

More and more women joined in for work, and that was when Miriam decided we should move to another building, where the old dining room used to be. There we started doing T-shirts. We even went into town to work on T-shirts and to learn more. A while later, Cait Wait arrived. She worked at the other end of the same building. She did her style of painting, while we did the T-shirts, and some women did screen-printing. Mrs Wallace taught some of the women to do screen-printing. Cait then saw what we were doing and she showed us her work. She decided we should work together as one, so we joined up and all worked together.

Cait showed us how to do lino block. I got to know how to work on the lino block and I was now cutting designs on to the blocks to put on T-shirts. I also sewed pillowcases so that the women could do designs on them. I used to sew dresses, skirts, kids shorts and tops. The women painted on the clothes I sewed.

Then Cait said to us we should ask for another building. We all decided to pick a spot for the new building. After a while, the builders came, and soon they started work on the building. After it was finished, Cait asked us what colour paint we would like the building to be painted and we picked green. We also wanted an air cooler to be put in. Then we thought about a name for our new building, and then I said to Mrs Wallace...Keringke is your Dreaming place, that's where your mother was born. Why don't we name this building Keringke. We called it Keringke, which means kangaroo tracks. It is Kangaroo Dreaming.

Atyelpe
(Kangaroo rat)

Story by Agnes Abbott

This is my grandfather's Dreaming, my mother's father. I am not telling someone else's story, I am telling my grandfather's story. It is about our country. That country belongs to us and we are taking care of it. Those kangaroo rats travelled from the Dreamtime. My mother's older brother used to tell us all that story, so we could continue to tell the story to our children and continue to look after that place.

Those kangaroo rats travelled from the south and they came this way. They came to Arlkwitarre and they stayed there. Arlkwitarre was a black hill right in the middle of a large sandhill, south of Therirrerte. They came there to the country between those two places. They stayed at a rockhole called Itampene, south of Therirrerte. After having stayed there for a short time, they moved to a place called Mernethenge and stayed there. They made their camp and slept there, stopping there for a while. Then they climbed up towards this place coming towards Therirrerte, and there they made that rockhole.

They made a lot of designs on the rocks there. Then they came on to Therirrerte and they stopped there. A lot of animals, including emus, bush turkeys and kangaroos, came there from many different places. They all came together from everywhere to that place. They came together in that one place. Then they spread out and went to different places. They came to Puraltneme and then moved on towards Anteyeteye. From Anteyeteye they went on to Narpipe and then moved on towards Inannge. At Inannge they made their designs in the cave. They stopped for a while at that place and did those designs. Then they travelled north for a long way and sat themselves down there feeling very tired, and that is where they remain.

Atyelpe was acquired by the Araluen Centre for Arts and Entertainment in Alice Springs. The work was made in 1992 and was first shown in an exhibition of the same name at the Te Taumata Gallery in Auckland, New Zealand. The work is a large one, tracing many sites located throughout the length and breadth of Eastern Arrernte country.

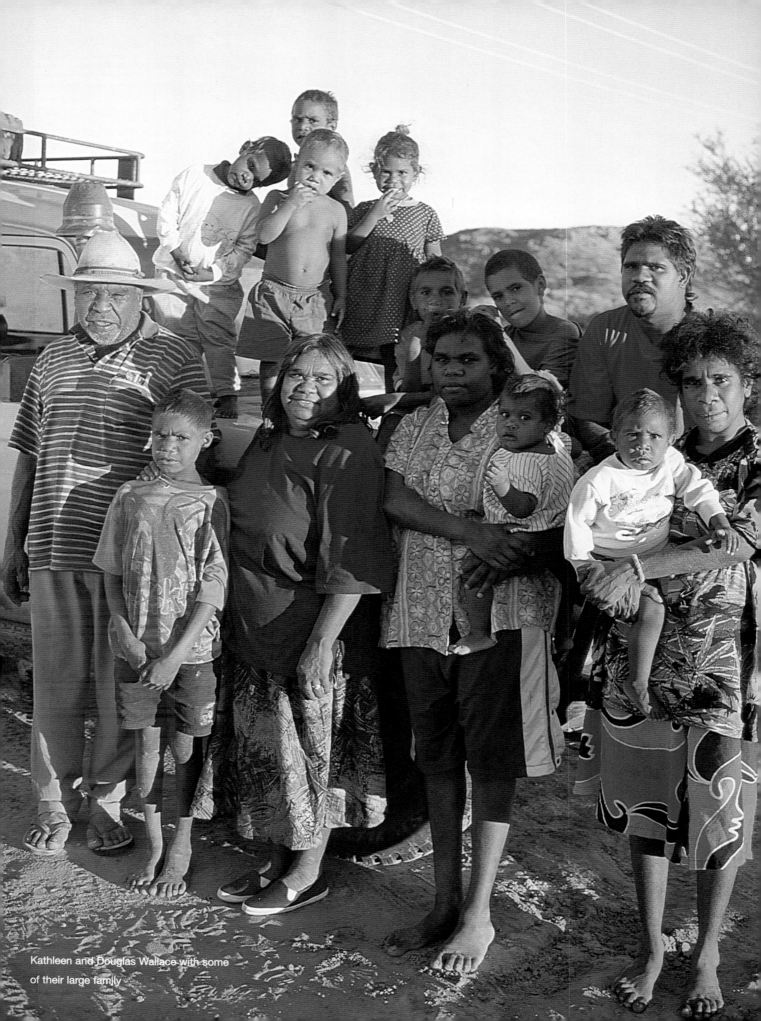

Kathleen and Douglas Wallace with some
of their large family

Keringke is my Dreaming place

Kathleen Wallace was born at Uyetye on Todd River Station, east of where the Santa Teresa Mission was developed. Her mother's country is Therirrerte and her father's country is Todd River side. The area incorporating Santa Teresa is the homeland of her grandfather (her mother's father). As the eldest child in her family, Kathleen was entrusted with his Dreaming stories. Kathleen is the custodian of many traditional stories of her country.

Kathleen was given her name by the nuns when she arrived at Santa Teresa Mission. Her birth date has been set as 1 July 1948, a date which is regularly issued to children or people with birth dates that are unknown. Kathleen has contributed much to her local community and the wider art community, both as a member of the Ltyentye Apurte Community Government Council and as a committee member on the Executive Committee of Desart, an independent association of Aboriginal art and craft centres in Central Australia. Kathleen has been one of the driving forces behind Keringke Arts and has been encouraging of the artists since its inception. A natural mentor and teacher, Kathleen has trained and encouraged many younger women in the community to become artists, and keeps an ever-watchful eye on

Detail of plate 1

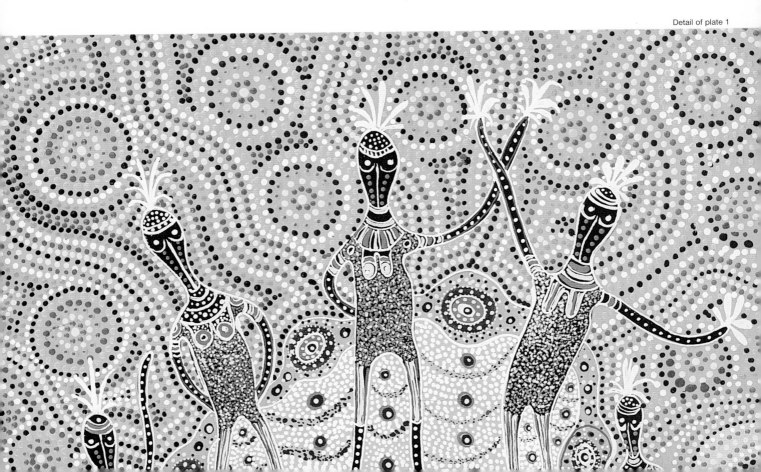

the works produced and distributed by Keringke Arts. Her encouragement and teaching have given rise to an energetic art centre with a highly creative team of artists. While each artist has now developed her own individual style, it is the bright colours and lyrical sensibility of Kathleen's work that has inspired the signature style of Keringke Arts.

I came here with my mother and father when I was a child. I didn't know this place was a mission or what the mission was. My culture was still strong. I knew every story told to me by my grandparents, my mother and father and all my relations. Everything that was taught to me is still with me. People who came here to the mission were from all over the country. They all had their own culture and stories and continued to practice their culture and ceremonial business. My parents brought me here and told me I had to go to school, to learn a new culture. I was still speaking my language when I started to learn English. I don't know if the mission knew about sacred sites, because where the buildings are now, that was really sacred. People used to follow each other's footprints through this area. They weren't allowed to get off the track. This is because we respected this place as a rainmaking place.

People would still gather seeds and look for kangaroo and goanna. Older people still used to hunt with spears and boomerangs. At the mission it was really different eating foods that I'd never seen before, like carrots, pumpkins, tomatoes, cauliflower, broccoli and lots of other vegetables. We'd eat them raw, like *alangkwe*, or bush banana.

My family returned to work on the station and I stayed in the dormitory until I was about nineteen. They used to come and visit me. My parents worked at Ringwood Station and sometimes at Numery Station. They used to work everywhere, building fences. For payment, they were given rations. Things like sugar, tea, flour, jam and tinned meat. They also got money each week, about seventy dollars. My parents eventually moved to the mission, but just for a little while, and then they moved out bush. My grandparents on my mother's side

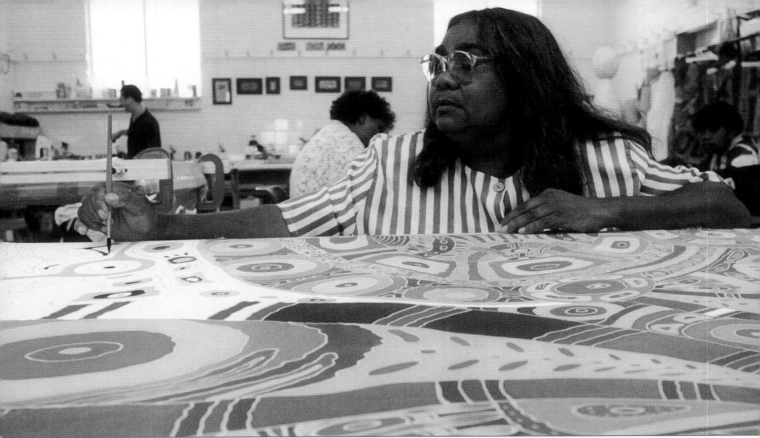

Photo: Peter Farrow

Kathleen Wallace painting a silk length

continued to live out bush near Little Well. I used to take my sister and brothers out there for holidays to visit. When I was still at school, we would travel into town for sports. People used to come in from other communities to play sports as well.

At this time, there wasn't any alcohol on the mission. Later on some people came from town to live on the mission and they used to bring alcohol without the priest knowing. It was in the late 1950s that they started to bring in the grog. My grandparents started drinking when they moved to the mission and my parents also used to drink. My mother died of cancer and alcohol-related problems and my father died from grog as well.

When I left school I was still living in the dormitory. My first job was working as a teaching assistant. For about three years, I taught pre-school and grade one. Then I started working for the mission, doing housework like cooking and cleaning. We used to cook meals for the teachers and mission staff. We were paid just a small amount, fifty cents a week. Grown-ups were given one pound. We used to buy small things like bobby pins and combs from the canteen. Working for the mission, we used to do everything perfectly, even cutting up vegetables. When

we were ironing, we used to do it perfectly, and when we did washing, we did it by hand, and would get into trouble if we didn't do it perfectly. We used to make the beds perfectly too.

When I was working as a teacher's assistant, I met my husband. He used to make bricks to build the houses. Before that, when he was very young, he worked on the station. He was my promised husband, that's why we got married. We got married in the church. I had to wear a veil, white dress and white shoes. He had to wear a white shirt, black trousers and a tie. We were married by the priest. There were lots of people at the wedding. The nuns had to get everything for me.

My husband and I were living together in the community. I didn't live in the dormitory any more. When I moved out of the dormitory, that's when I started looking after kids. I had to look after my brothers and sister because my parents started drinking. Alcohol was starting to be a problem. When I was in Alice Springs I used to look after my parents when they were drunk, and my brothers and sister. I started to know about alcohol then, but I didn't like it. I never had any, because when I used to see my parents go real funny, I didn't want to touch it. In the 1950s Aboriginal people weren't allowed to drink in the town pubs, so my parents would hide in the hills or down at the creek. I would come in to town for holidays and have to look after my parents drinking in the creek. My parents used to work on a pig farm in town with my father's mother. I never played with the other kids, I always stayed home to look after my brothers and sister, and sometimes my parents.

When I was about fifteen or sixteen, I brought my brothers and sister back to Santa Teresa as they had started to drink with my parents. From that time on, I also started caring for many children that were suffering from drinking parents. When they used to get hungry they would come to me. I played a big part in bringing up my brothers and sister: Maurice, Timothy, Susan [deceased] and Gregory. After I married Douglas, we grew up many of the kids on his side, most of his nieces and nephews. There was Margaret, Jacqueline, Roslyn, Johnny, Cindy and Colleen Wallace. We also raised Douglas's cousin-brother's daughters, Dianne,

Priscilla and Jeannie Furber, along with their cousins, Stanley, Matthew and Calvin Furber. Once Douglas's niece Margaret was brought up, we also supported her children, Travis, Trenten and Robert Wallace—our grandchildren. On my side of the family, we also brought up Denise and Michael Hayes—my grandchildren, who are the children of Jack Hayes, the son of old Bruce Hayes, my cousin-brother who was married to Douglas's sister Kathleen Hayes [nee Wallace, now deceased]. I am still growing up kids, the current ones being my nieces and nephews: Denise Doolan, Maurice's daughter; Neville, Kerry and Anthony Doolan—Gregory's sons; and Johnny Doolan, Susan's son. All in all, we have raised, and continue to raise, some twenty-six children, yet I have borne no children myself. All these people call me Mum, and Douglas, Dad or Mamame.

After a long time working as a teaching assistant at the school, I was sent up to Darwin to do training as a teacher. When I came back from Darwin, I was still working as a teaching assistant. A few years later we did more training to become teachers. We were taught by a brother who lived at Santa Teresa, and got teaching certificates. Then we got more training, same thing again. We had people come to the community from Batchelor College. We also used to travel in to town to Batchelor College. Before that we had to go to Darwin, but now we have our own Batchelor College. It was really hard for us to go to another place, we used to miss our family and our relations.

When I first started painting I was at school. The nuns used to teach us how to do painting. We were given a piece of paper and coloured pencils to do drawing. I remember when I was a child, my relations used to do corroboree and do painting on their bodies. That was still happening. Some years later a teacher named Miriam came to live at Santa Teresa. Miriam worked at the school, and after quite a few years, she started to teach us pottery, leatherwork, screen-printing and some other types of art in the craft centre. More women started to come in and work with us. Some older women came and learned to do sewing and there were younger women who came and learned to do screen-printing. They did the screen-printing on T-shirts.

We were still working at the same building when Cait Wait arrived. Cait was an artist herself. She worked with us and had a different technique of working to show us. Lino-printing was another thing we learned to do. From that time on we were taught to do silk painting. It was different to doing lino-printing. We also learned about painting on nylon material.

The work we were doing was getting bigger and bigger. We wanted a larger building. It was built right where the old hospital used to be. When the building was finished we moved in. We wanted to have a name to call the art centre. I went and asked my grandmother's brother to see if it would be all right to give the art centre an Aboriginal placename. He suggested *atyenhenge atherre*, which means 'grandfather and grandson', the two large rocks which sit on the hill behind the community, but that name didn't feel right. Then I asked him if we could use Keringke for the name of the art centre, and after thinking about it for a while, he agreed. Keringke is my Dreaming place. It is where my mother's life started and it is my grandfather's homeland. That's why it's called Keringke.

All my adult life I've been teaching stories, all the old stories and paintings that my mother's parents taught me. I would like to keep on teaching. That's important, to pass on my knowledge.

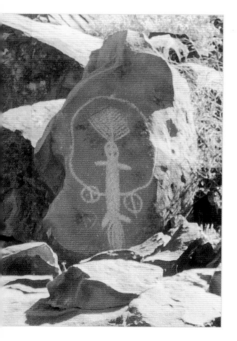

Rock art at Therirrerte
showing the Woman from the
Dreamtime

Arelhe Altyerrenge Alhe Aneke

(The woman from the Dreamtime)

Story by Kathleen Wallace

This is a story from the Dreamtime about a woman. This woman [see plate 2] came from the south, a young woman. She ran across the desert from the men chasing her. She didn't want the men to get her. She was pregnant, but she didn't know and became sick. She went to Therirrerte and hid herself there. There was water in the rockhole and so she found out she was bleeding. She then had a miscarriage. She washed herself and then she died there because she had lost so much blood. Her spirit is there now and there is still a pink stain on the rock from her blood. After, little birds came in from the plains to drink the water, they laid their eggs on the rocks and you can see their tracks there to this day. All the rock paintings remain and when it rains, pink water runs out from the rockhole as a result of the woman's miscarriage. The woman is still painted on the rock.

Irrernte-arenye

(Spirit figures)

Story by Kathleen Wallace

Therirrerte, along with other sacred sites and special places throughout Eastern Arrernte country, is also home to the spirit figures called *irrernte-arenye* [see plate 3]. Translated, the name of these figures literally means 'belonging to the cold'. Once living people, these ancestor spirits are said to live in the cold place. The *irrernte-arenye* look after the place where they live, watching out for and guiding the people from their families. They can get you lost if they don't know you, or if you don't belong to that place, but they will still look after you. They can still be heard singing at Therirrerte and other sacred sites.

Artworks

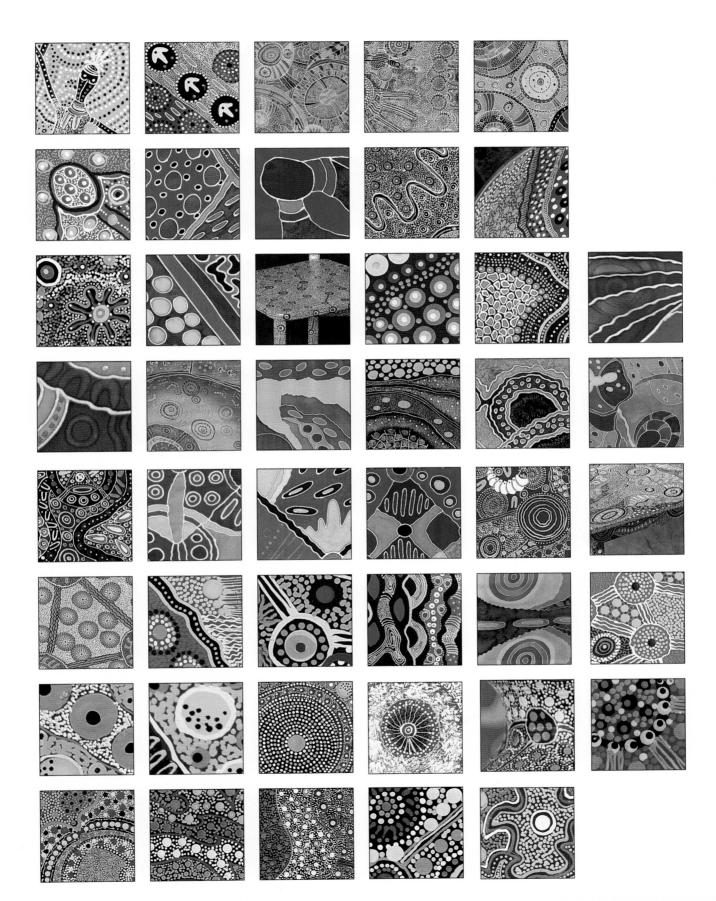

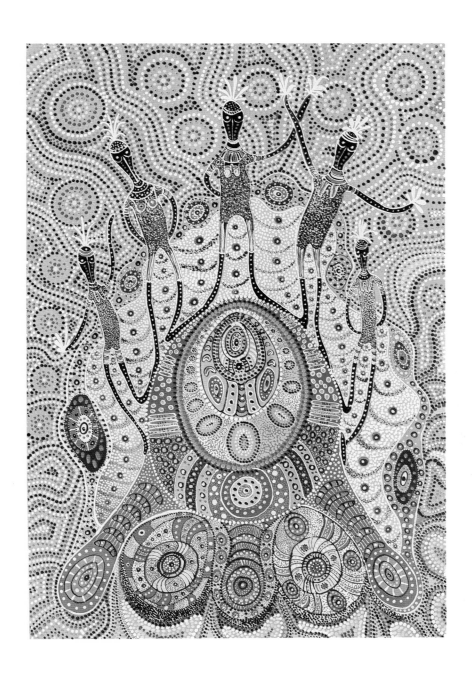

 Kathleen Wallace
Dancing Women, 1997

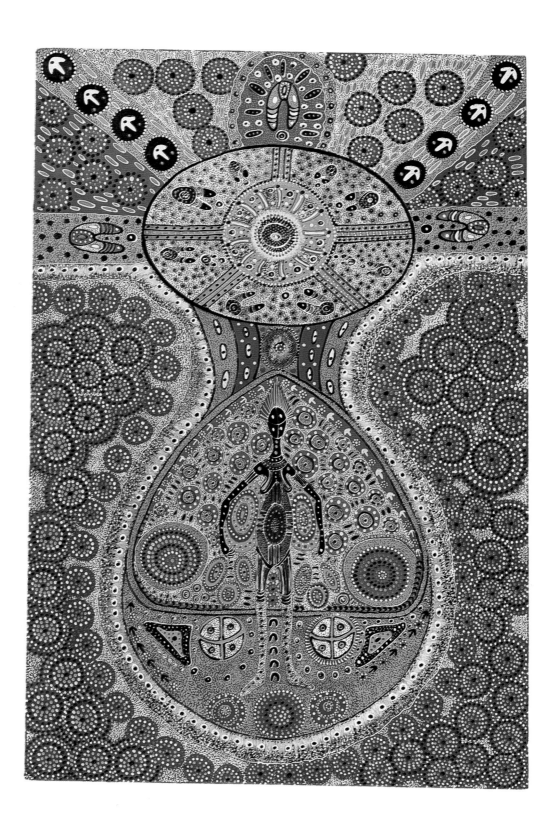

2

Kathleen Wallace

Arelhe Altyerrenge Alhe Aneke (Woman from the Dreamtime), 1997

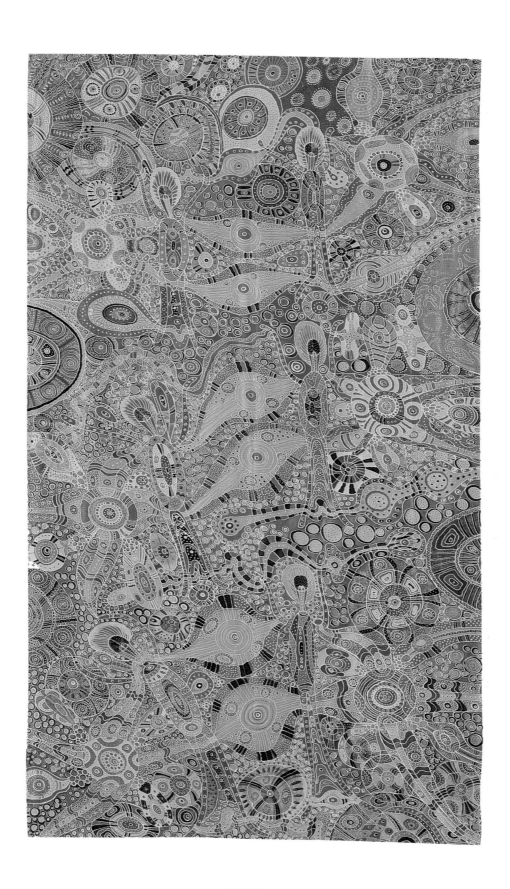

3 Kathleen Wallace

Irrernte-arenye Singing, 1997

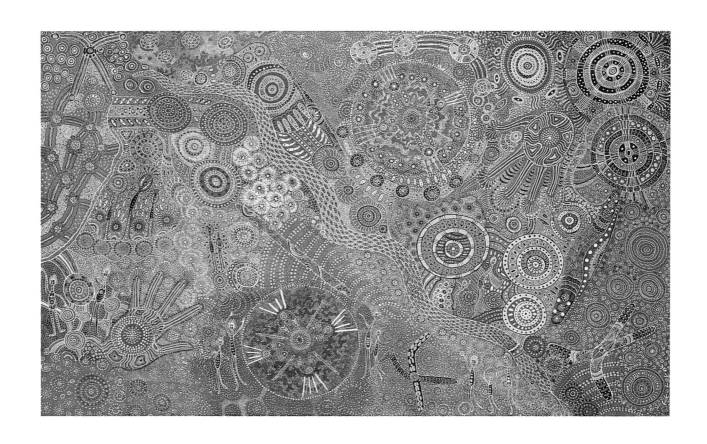

4 Kathleen Wallace
Kwelaye (Rainbow Snake), 1997–98

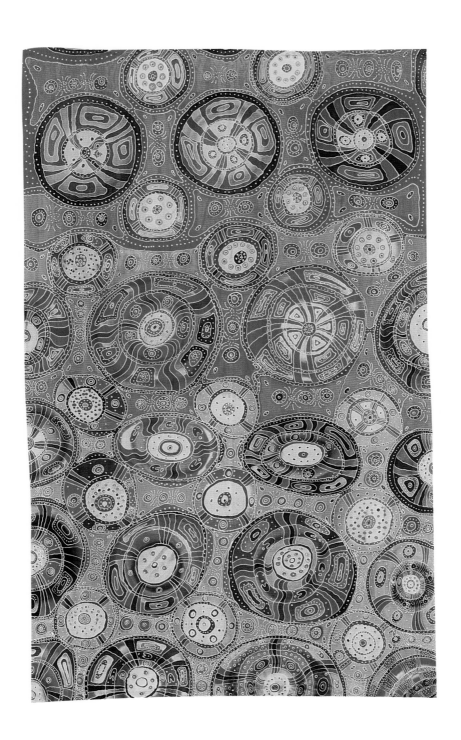

5 Kathleen Wallace
Untitled, 1997

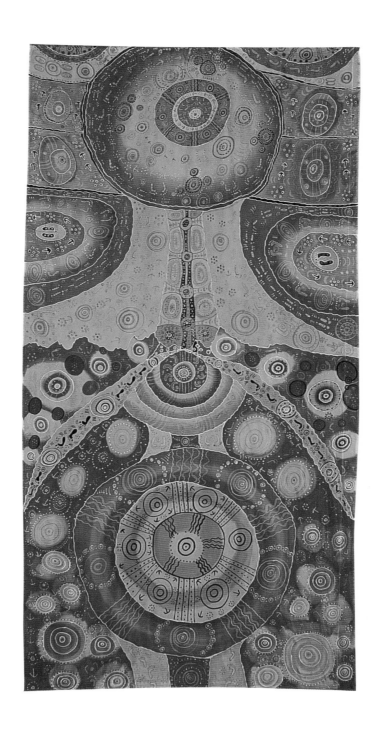

6 Kathleen Wallace

Atyemeye-kenhe Impatye (Grandfather's Tracks), 1996

7 Bridgette Wallace
Untitled, 1997

8 Bridgette Wallace
 Untitled, 1997

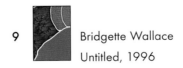

9 Bridgette Wallace
Untitled, 1996

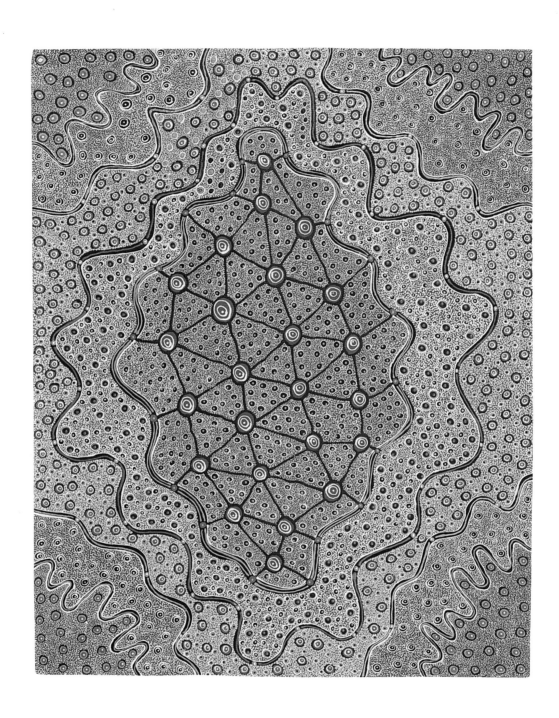

10 Bridgette Wallace
 Untitled, 1997

 11 June Smith
Untitled, 1998

12 June Smith
Untitled, 1998

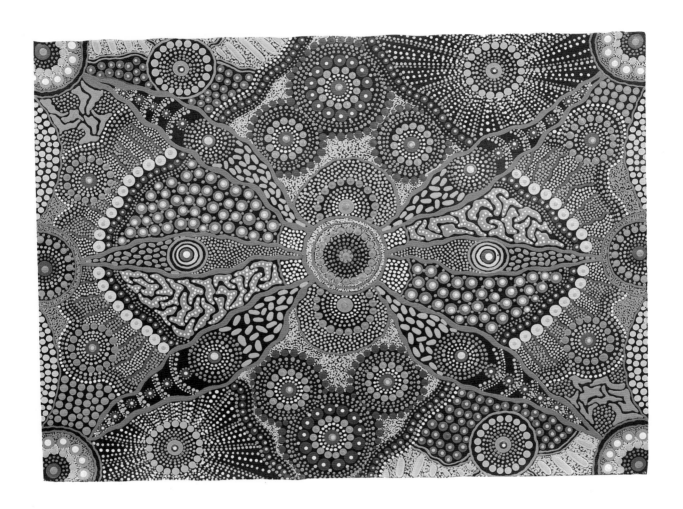

13 Mary Oliver
Untitled, 1998

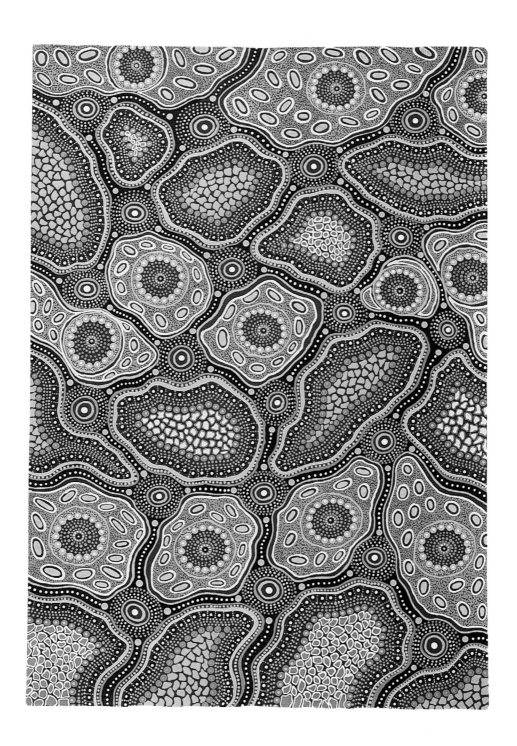

14 Mary Oliver
Untitled, 1998

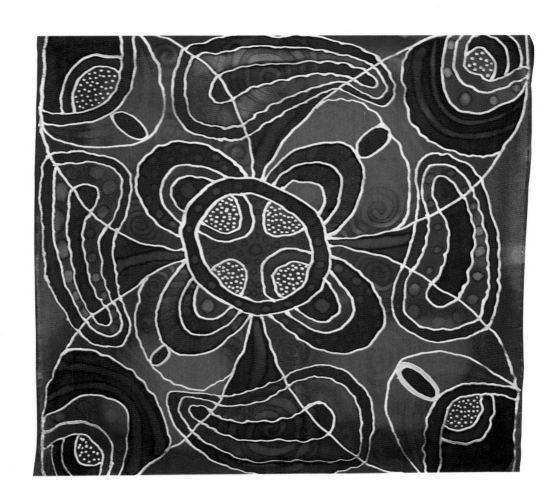

15 Mary Oliver
 Untitled, 1995

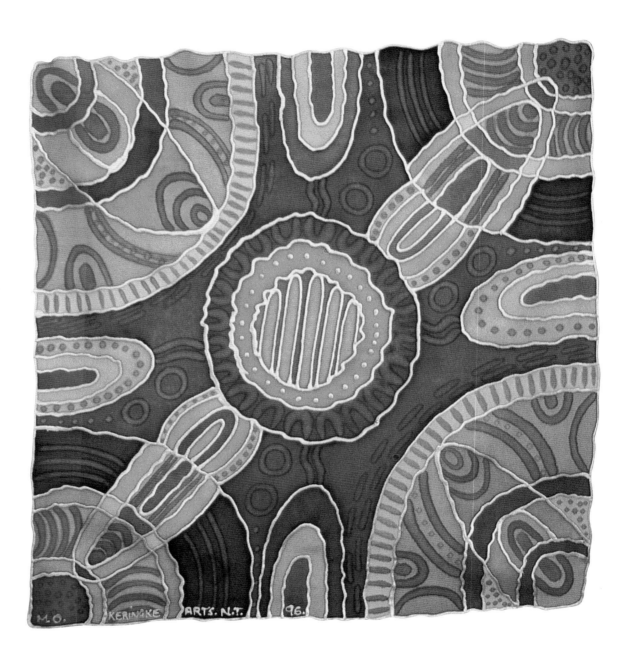

 16 Mary Oliver
Untitled, 1996

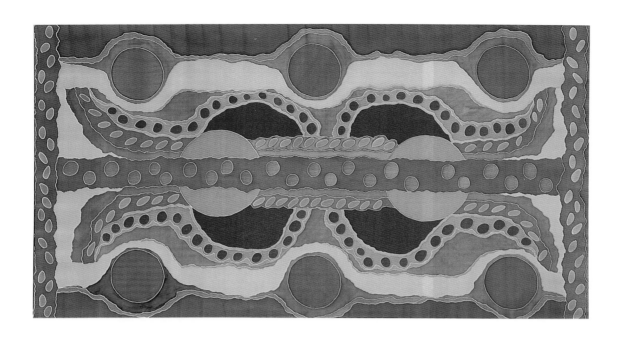

17

Camilla Young
Untitled, 1997

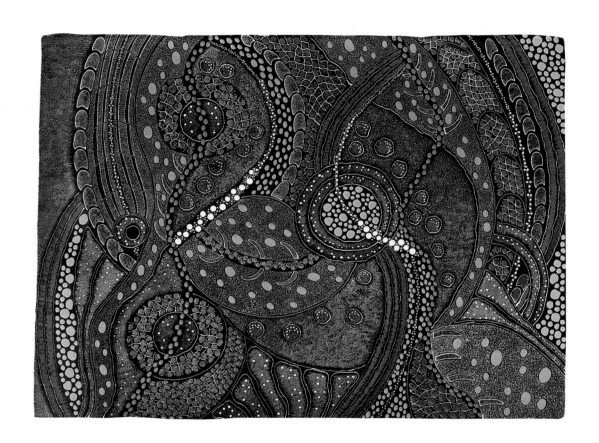

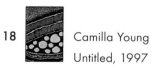

18 Camilla Young
Untitled, 1997

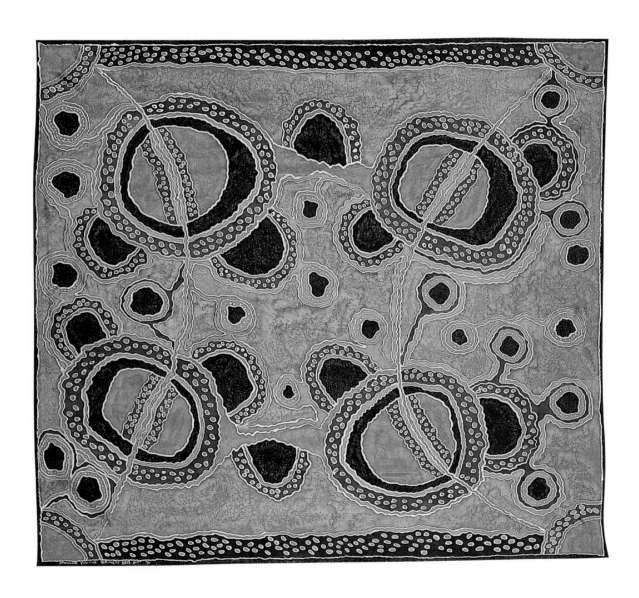

19

Camilla Young
Untitled, 1997

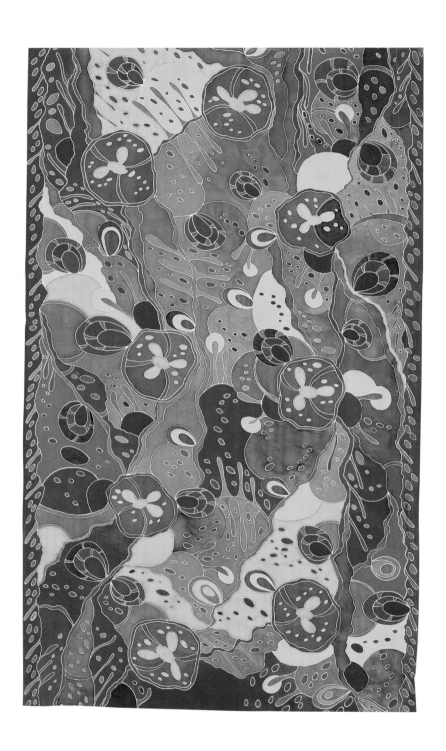

20 Camilla Young
 Untitled, 1997

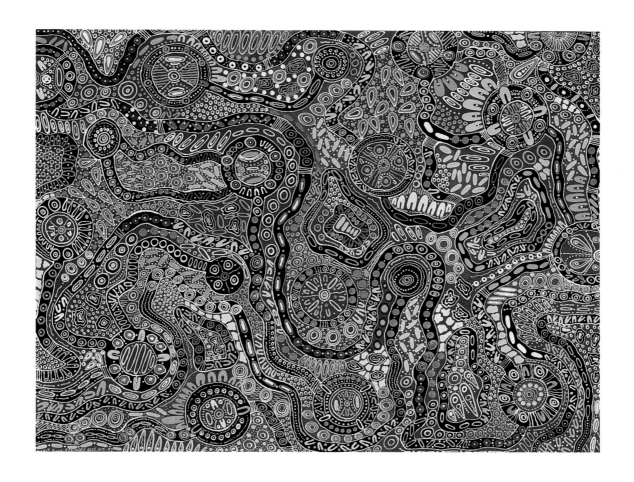

21 Marie Young
Untitled, 1997

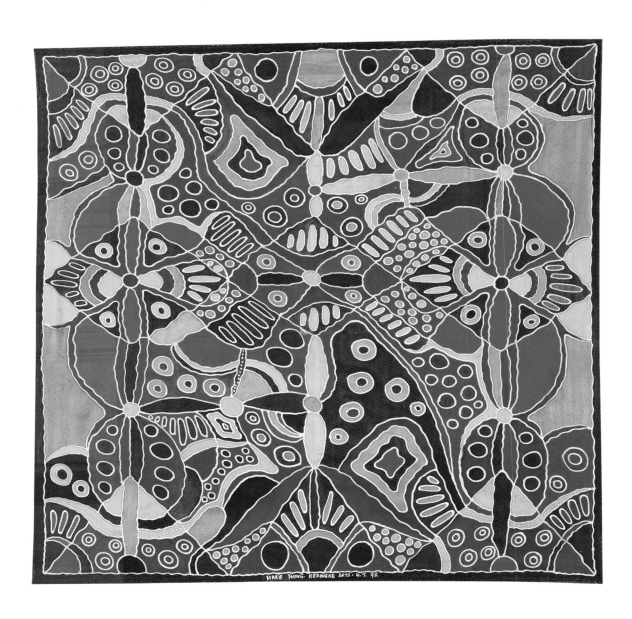

22 Marie Young
Untitled, 1998

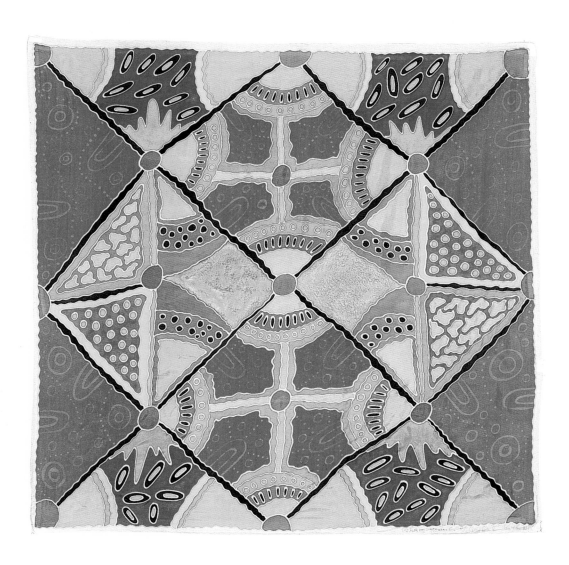

23 Marie Young
Untitled, 1998

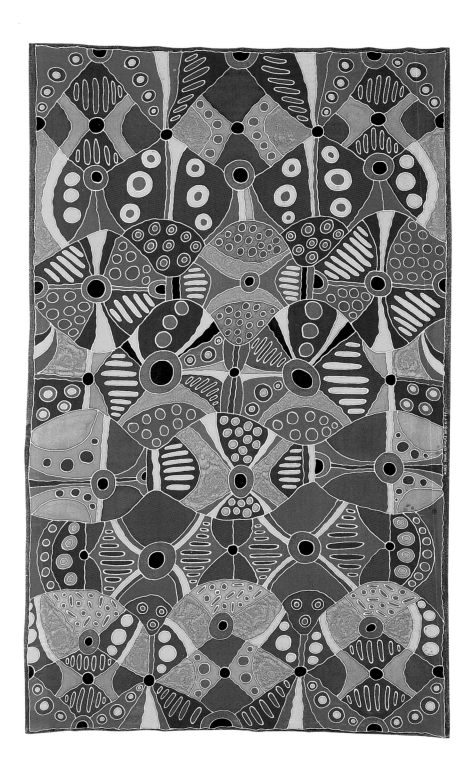

24 Marie Young
 Untitled, 1997

25 Marie Young
Untitled, 1997

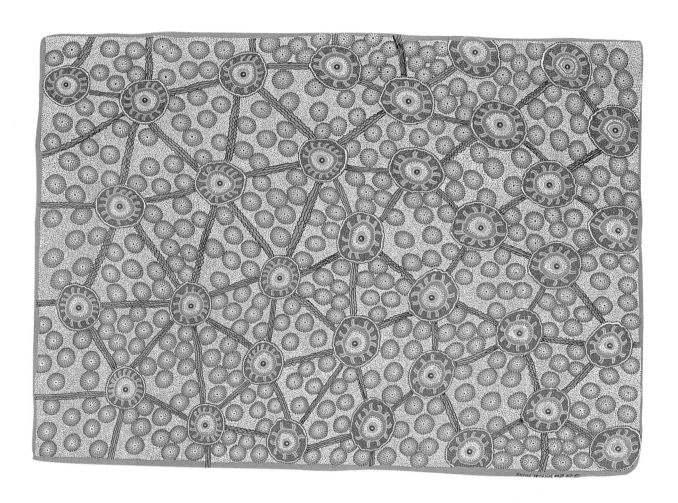

26 Jane Oliver
Untitled, 1997

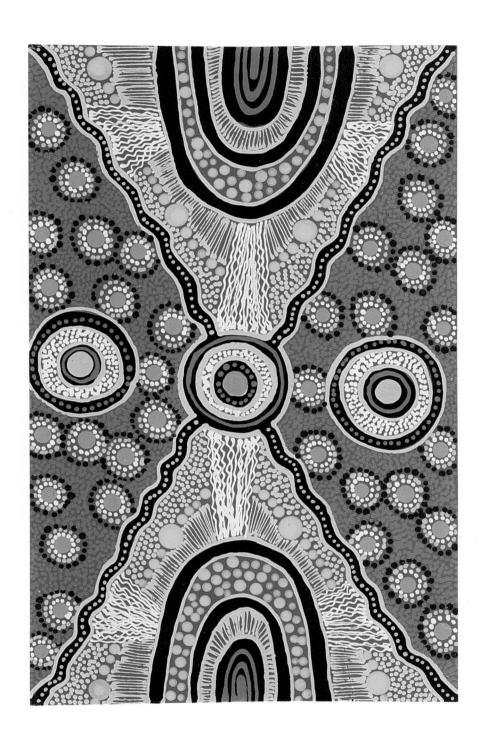

27 Jane Oliver
Untitled, 1997

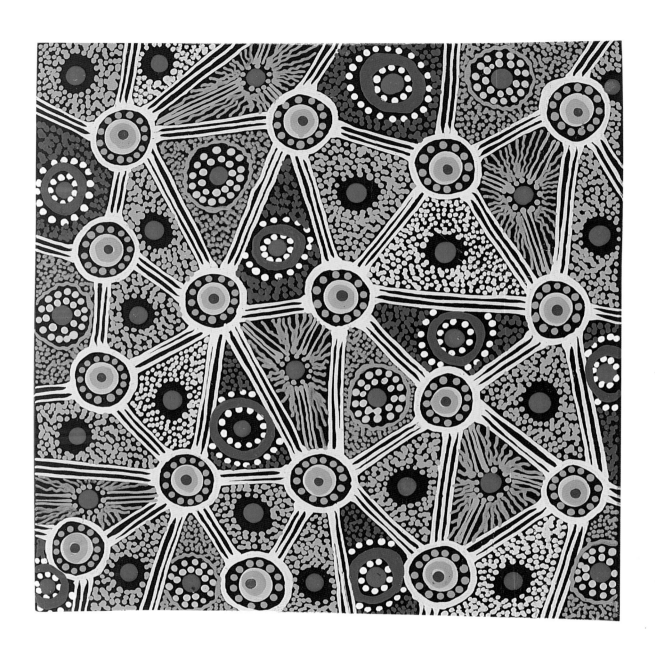

28 Jane Oliver
Untitled, 1997

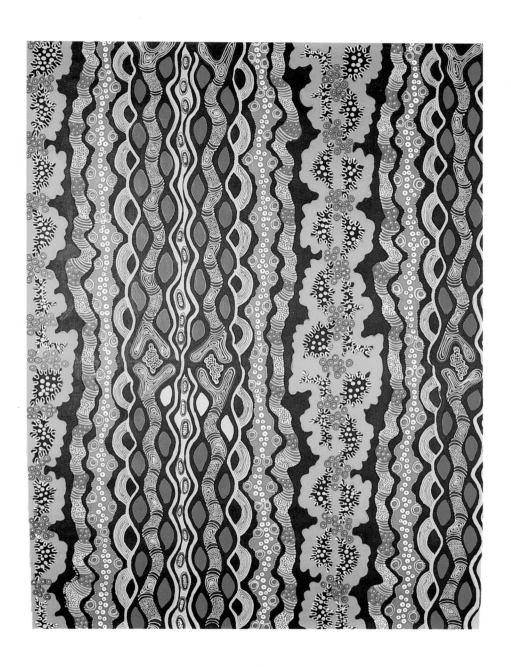

29 Jane Oliver
Untitled, 1996

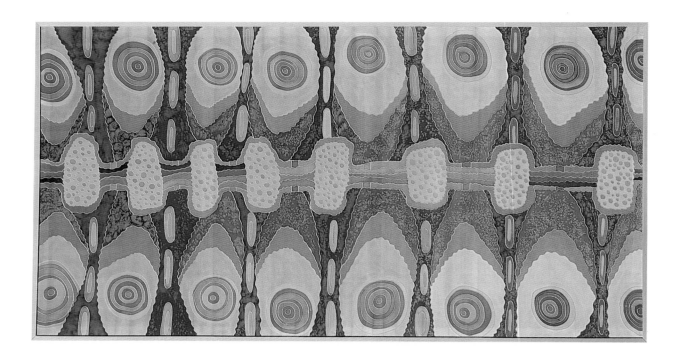

30 Jane Oliver
Untitled, 1997

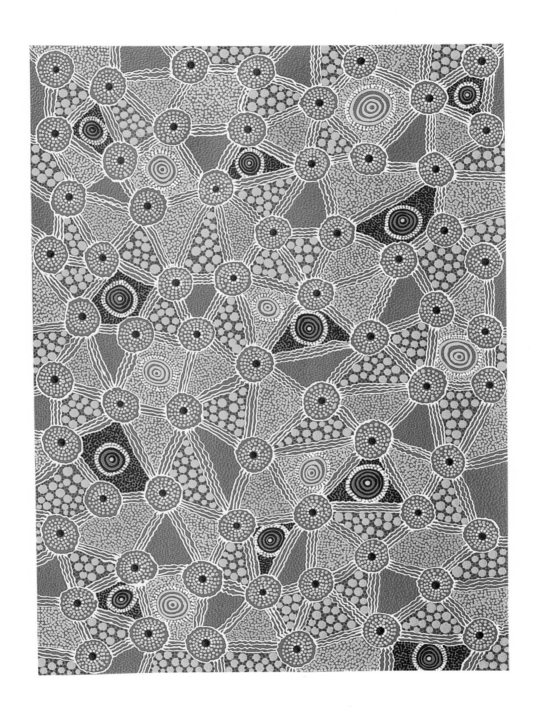

31 Jane Oliver
Untitled, 1997

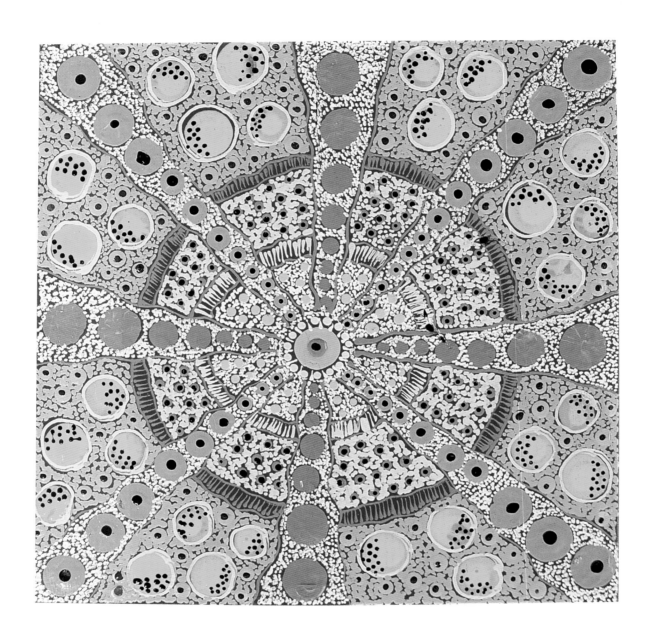

32 Serena Hayes
Untitled, 1997

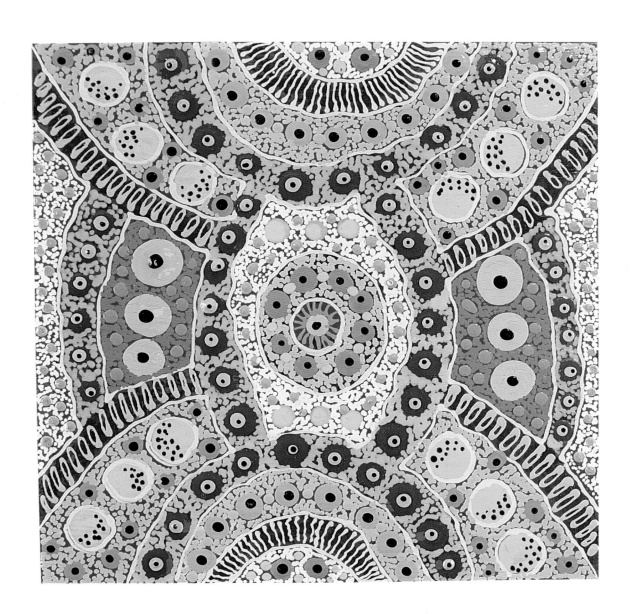

33 Serena Hayes
Untitled, 1997

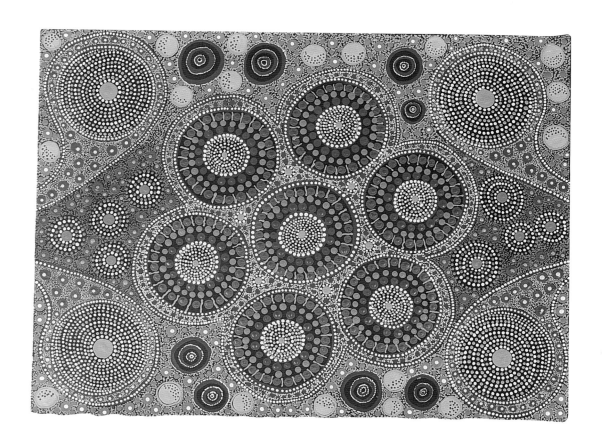

34 Serena Hayes
Untitled, 1998

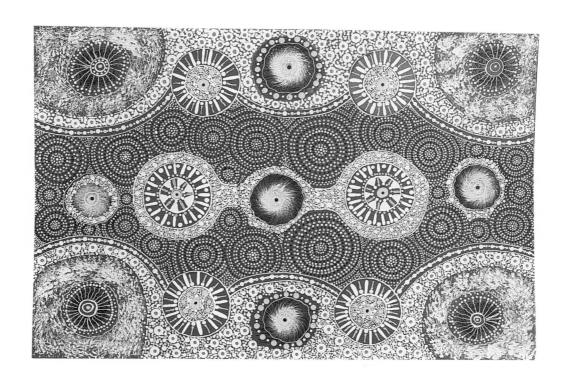

35 Serena Hayes
Untitled, 1997

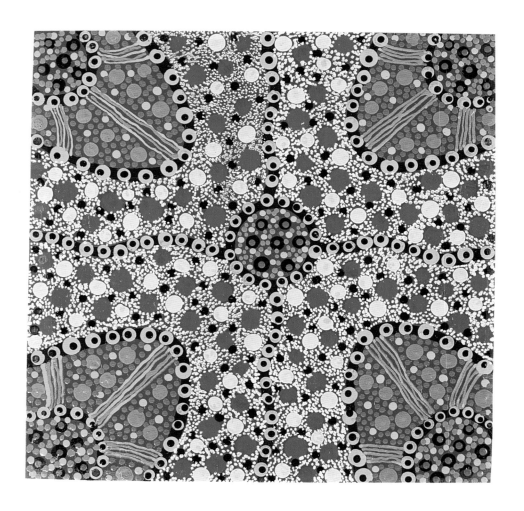

36 Bernadette Wallace
Untitled, 1997

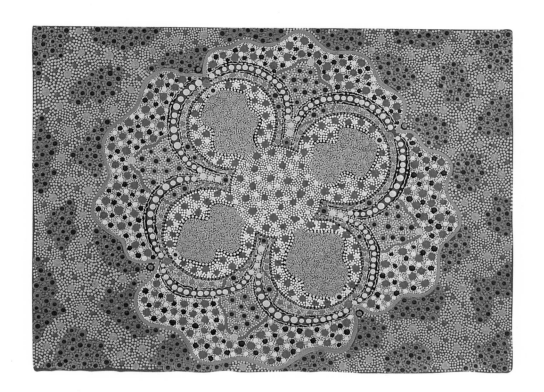

37 Bernadette Wallace
Untitled, 1997

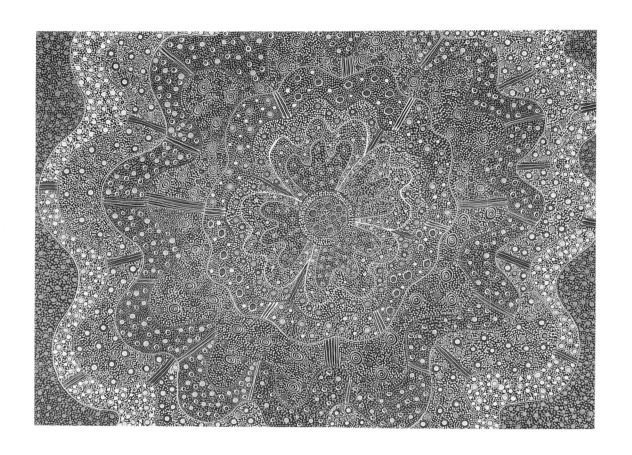

38 Sharon Williams
Untitled, 1997

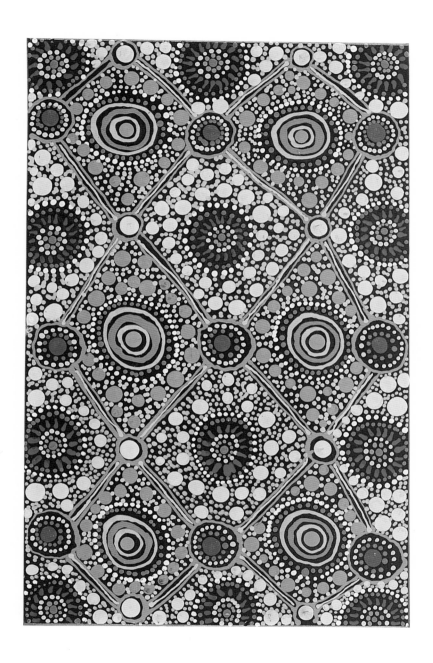

39 Sharon Williams
Untitled, 1997

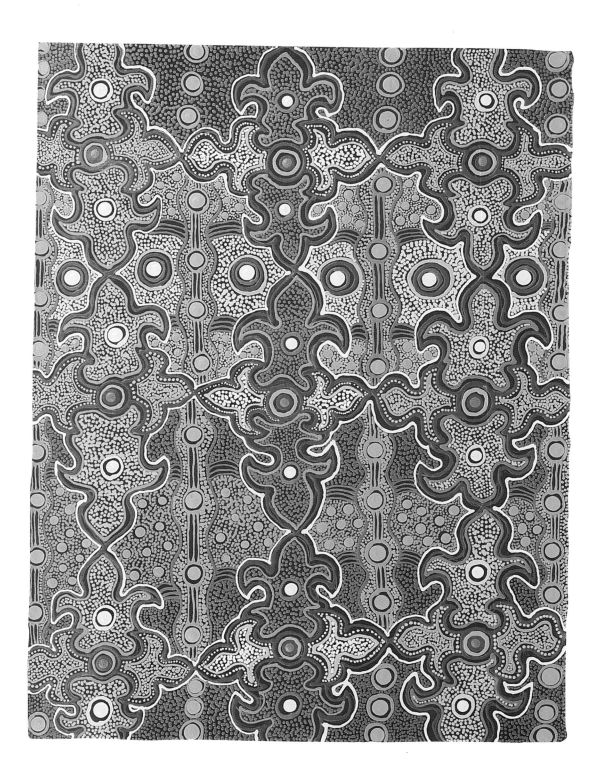

40 Sharon Williams
Untitled, 1998

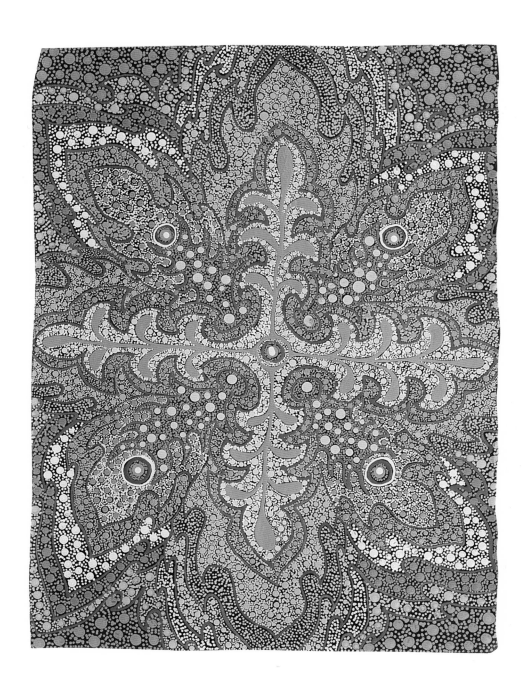

 41 Sharon Williams
Untitled, 1998

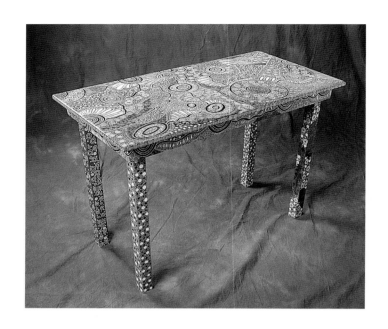

 42 Marie Young
Table, 1996

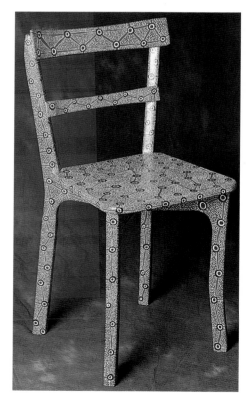

 43 Bridgette Wallace
Chair, 1996

44 Sharon Williams
Vase, 1997

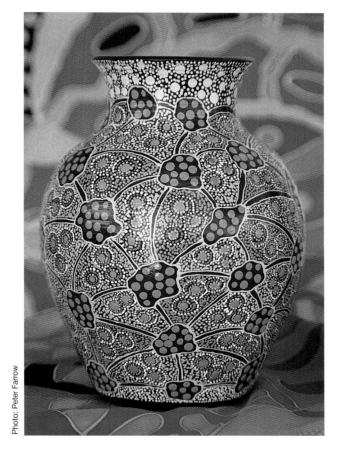

Photo: Peter Farrow

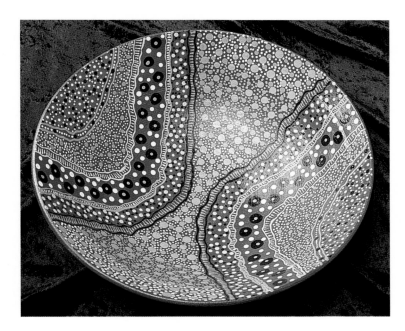

45 Bridgette Wallace
Bowl, 1996

The artists

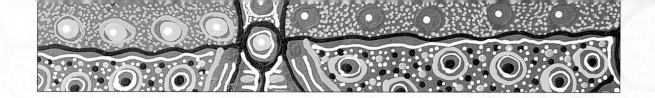

Bridgette Wallace

Bridgette Wallace is one of the founding artists at Keringke and is devoted to the practice of her work. Bridgette's art reflects the living nature of the desert environment. The red oxide underlying the layers of colour in most of Bridgette's art is the red soil of her home. A common structure in Bridgette's work is a web-like design of lines connecting to circles—single lines to single circles—definitive pathways that map out her strong connections to family and places.

I have been working with Keringke Arts since it started. I do my own designs when I paint, I don't get ideas from anyone else. It all comes from inside. I like painting silks the most, 90 X 90 silks, as well as long silks and small square ones and medium ones. I paint my designs on chairs, boomerangs, boxes, photo frames, mirrors and paper, as well as other things.

I think Keringke Arts plays an important role in the community. It has a good reputation in the industry throughout Australia. There is a really good working environment at Keringke Arts. Working here has given me the training in silk painting, in pricing my own work and in marketing. I think it's important to pass on our knowledge about art to the younger children. Keringke Arts is known for its high quality artworks and the quality has continued to increase in recent years.

Liesl Rockchild was a good coordinator. With her we went on a trip to Ayers Rock and sold lots of things. We also went to Sydney for an exhibition, which went really well. Everything was sold. I have also travelled to New Zealand with Cait Wait and some of the other ladies from Keringke Arts: Miriam, Kathleen Wallace, Gabriella Wallace, Jane Young, Mary Oliver, Elaine Hayes, June Smith and Faye Oliver. I also took my little boy with me, Alvin, and he was about four years old then. We sold lots of things. It was a very cold place.

I was born at Santa Teresa Mission and have lived here for a long time. I grew up here with my parents. My father's name is Don Wallace and my mother has passed away. I like visiting Alice Springs and Maryvale Station as well as going out bush around Santa Teresa. I intend to stay here at Santa Teresa. This is my home.

June Smith

Highly fluid, with a floating kinetic energy, the works by June Smith, especially those conceived on silk, capture the excitement the artist feels as the designs formulated in her imagination actually come to life. June's work pushes the boundaries and possibilities of colour combination, where bright colours are set against dark to attain striking compositional structures.

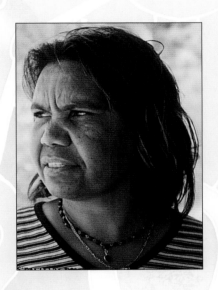

The ideas for my work come to me as I paint. I used to do a lot of painting and artwork at school and the feeling to paint has stayed with me ever since. When the art centre came along, I went to work there and that's how I've kept going, doing my designs. It's just designs.

I most enjoy painting on silk because it's easy and I like doing it. I was the first person at Keringke to do painting on silk. I also like painting on paper and other things, like boxes, pottery bowls and wooden frames. I think it's good that the art centre's still here and it's going strong. The women who are working here really want to be here doing art. I think Keringke Arts has a good reputation because we've got a lot of good things going on and happening here. All the artists are happy working here together. We get along together, talking to each other as we do our artwork, and it's good.

I reckon it's important to have art centres in communities. With all of us working together, we can set things up properly and, with the things we make, we know we will make good money for what we do. It's also good because some kids come up here and watch us work sometimes, even do a bit themselves. If they like what they see, maybe when they leave school they might work here too. I reckon there's good things here, because it's quality work. There's always orders coming in from cities all over the place. I think our work is always getting better and better. I have been on a few trips with Keringke Arts, the first one was to the arts and craft show at the Sydney Showgrounds, and my second was to New Zealand.

I was born in Alice Springs and went to school there. When I finished school in Alice Springs, I came to live here at Ltyentye Apurte. The first job I had was with Sister Edith, she taught us pottery and leatherwork. I've been at Santa Teresa half my life now and I like living here. I will always live here, because this is where my three children grew up.

Mary Oliver

Mary Oliver is one of the original Keringke artists, having started work at the art centre in 1987. Her work features clean lines and fine details, with a very earthy and organic use of colour. Whether they be on silk, paper, ceramics or any other medium, the fluidity of her designs is usually given added emphasis by her use of mirror imaging. Mary's work has been reproduced on calendars, diaries and cards by Community Aid Abroad. In 1997 her entry in the National Aboriginal and Torres Strait Islander Art Award was selected to be part of the national touring exhibition.

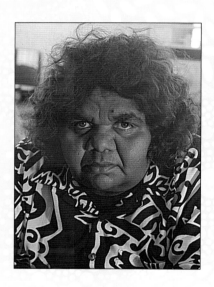

I like painting on silk because it is quick to do and the colours are really bright. I still enjoy doing it now, but I like doing other things too, like painting on ceramic bowls and vases and painting on paper. The thing I have enjoyed doing most is painting silk lengths, which can be up to four metres long. We used to put them in exhibitions. I have also enjoyed doing the smaller silk scarves.

I grew up and went to school here at Santa Teresa. My family moved to Amoonguna when I was in high school and I went to Alice Springs High. Then we moved back to Santa Teresa and I finished off school here. I was about seventeen then. After I left school, I worked at the community store for a while, then at the bank, and then at the orchard. After that I started working with Rachel Palmer, teaching the kids in the school art room.

When Cait Wait arrived, I started learning about doing lino blocks on T-shirts and other ways of making art. Cait taught us a lot. We used to cut stencils out of thick paper and put them over the T-shirts and singlets, and paint over the top to get the design to go on. After Cait came, we moved to another building where ladies did sewing, making skirts, dresses and pillowcases. Some time after that we moved in to our new Keringke Arts Centre. After working for a little while in the new building, I started working doing the bookwork and looking after the office. June Smith and I did it together.

After Cait Wait we had another coordinator, Liesl Rockchild, working with us and we went away on some trips. One was to the Tiwi Islands to see the work they were doing there. After we came back from that trip, our work was put into the Northern Territory Art Award.

Serena Hayes

Serena Hayes worked at Keringke Arts for a short while in 1990 before leaving to start her family. She has three children. A quiet and consistent worker with a great sense of humour and fun, she returned to painting with immense enthusiasm in 1997. Serena was born in Alice Springs in 1973 and grew up at Santa Teresa with her mother and father. She is a traditional owner of the Santa Teresa area and her Dreaming is the rainbow, or as it is known in Arrernte, *mpwelarre*.

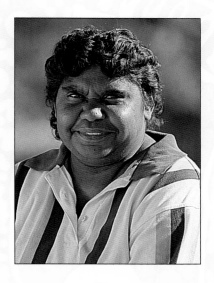

Long before Keringke Arts I used to go and watch my mother doing pottery. On the opening day of Keringke Arts there was a very big crowd. We had our own Keringke Arts Centre and the coordinator's name was Cait Wait. I got a job at Keringke and that's where I first learnt about linocuts, how to cut the designs and then put the designs onto T-shirts. Cait showed me how to do it. I started doing it on my own, cutting my own designs on lino blocks and then putting them on T-shirts. I wasn't really good at first, but I thought about giving it a go and after a while I succeeded. I learnt about silk and how to do painting on it. Then I was doing paintings on T-shirts, silk and also on shoes. I was getting better and better.

Sometimes we'd go out bush to have a look at country. We went to Auntie Aggie's country at Therirrerte and saw the big mob of designs on rocks and also an old camp where people lived in the early days.

After working at the art centre for a while, I decided I needed a bit of a change and left. I returned to Keringke in early 1997 and started off doing small things like giftboxes and some small boomerangs. My designs weren't the best when I started back at Keringke. I used to take it steady and watch the other artists work, doing their designs, doing it very neatly. I picked it up a little at a time and now I am good at it. I started doing bigger lengths of silk, painting on photo frames and also on bigger sized boomerangs.

My designs are good now. A lot of people buy my work, they sell very well. I have my designs in my head, they are always there. I especially like doing paintings for exhibitions. I feel satisfied now that everything's turning out good for me. All I want to do now is keep working here at Keringke Arts and keep on doing art here. That's the feeling I have inside me now, that I'll always be working here.

Camilla Young

Camilla Young has a strong visual repertoire and receives regular commissions for her work. Her silk paintings are characterised by large expanses of colour which flow in gentle rhythms across the surface. Combining elements from the earth and the heavens, her works are quite abstract in their appearance, expressing a knowledge and appreciation of her environment. Camilla's paintings on paper and other surfaces are characterised by earthy colours and intricate detail, and combine brushwork, dotting and sinuous lines to depict symbolic and representational featrures of the landscape. Camilla started at Keringke Arts as the trainee office manager in 1995, and is now the assistant coordinator.

When I started at Keringke, I used to work in the office in the mornings and do artwork in the afternoon. I started off not knowing much about art, but now I do it all the time. I used to watch Mrs Wallace painting and then I would get my own ideas. I started off with small things, like giftboxes, and then as I got better I started doing bigger works.

I was born at Ltyentye Apurte, where I also went to school. I went away to Melbourne for high school then came back to Santa Teresa. I got a job at the bank for a few years and then I worked at the school office. After working at the school I went with my family to live at Amoonguna. I came back to Santa Teresa and worked at the women's centre doing office work, then I went to live in Alice Springs. While I was living in town, my auntie, Kathleen Wallace, and the Keringke Arts Centre coordinator, Liesl Rockchild, offered me the job as trainee office manager at Keringke. I accepted and moved back to Santa Teresa.

My first trip with the art centre was to Darwin, to the Northern Territory Expo, where Desart was promoting art centres of Central Australia. We took a lot of work from Keringke, Hermannsburg and Jukurrpa Arts. It was a good experience to see how many people were interested in Aboriginal Art.

We have a new coordinator, a male coordinator now. It's quite different having a man to work with. I was so used to working with a woman coordinator, but it's been going really well since he's been here. I like being an artist and being involved in the business side at Keringke. I hope we can make it really successful so that it will be here for the younger children on the community who may be interested in doing art when they leave school.

Marie Young

The bright colours and intricate designs of Marie Young's silk paintings are reminiscent of stained glass. Her compositions are generally very symmetrical; the circular motifs, which are often representative of waterholes, resting places or campsites, make connections between all the elements within her work. Marie's paintings on canvas, paper and wood are completely different. In these works the imagery usually turns to local bushtucker, with witchetty grubs and bush bananas featuring most prominently. Campsites and the tracks of women with their digging sticks are also often represented, while other paintings are symbolic representations of the landscape.

I wasn't very good at artwork when I first started working here, so my auntie, Kathleen Wallace, helped me out. Since then I have been painting at Keringke Arts and enjoy everything I do.

I was born in Alice Springs and went to the convent school there. When I left school we moved back to the mission and stayed out here for a while before moving to Amoonguna. At that time, I was asked to go to Darwin for a teacher's training course and when I finished that, I stayed on in Darwin for four years. After Darwin, I came back to the mission. My sister Camilla asked me if I wanted to work at Keringke with her and so I started working there. I used to take photos of the artworks and put them in albums. I also used to pack all the orders and write the artists' names down for the artwork that they did.

We send our works away to be put in exhibitions in places like Araluen in Alice Springs, and also to Melbourne, Sydney and Cairns. While some artists go away to help promote the exhibitions, the rest stay on and keep Keringke Arts going. At the end of each work day, I work on my paintings at home.

Jane Oliver

The works by Jane Oliver are highly graphic in nature and resolute in their fine detail, clean lines and intricate designs. While obviously relating to images of cultural significance, the colour and form of Jane's imagery are also informed by many contemporary sources.

I was born in Alice Springs and grew up and went to school at Santa Teresa. Before I turned eighteen, I did work experience in arts and learned about paints, and also about different sorts of brushes and fabric paints and how to use acrylic on wood. When I left school I got a job at the art centre.

From then onwards, I have been working here. I first started painting on T-shirts, silks, photo frames and also on fabric lengths with acrylic. I learnt to do painting on canvas and also on wood. I have also done a workshop on oils. With the silks, I started doing 90 X 90 cm scarves and then moved on to long and short lengths. I also went away to Batchelor College for a year and learned about arts and crafts and different styles and techniques. Kwementyaye Rockchild was my first coordinator at Keringke.

Some time ago, some people came to see our work here at Keringke. Some of them were from Adelaide. They were interested in some of the prints we did and wanted to take them away so they could put them on fabric, cards, mats and giftwrap. They were from Community Aid Abroad. My works have been reproduced in their calendars and diaries and also as giftwrap. A lot of our works have been in exhibitions in Sydney, Adelaide, Darwin and at Araluen in Alice Springs.

Bernadette Wallace

Bernadette started painting at the art centre in 1995. Bernadette's painting style is very atmospheric, her extremely fine dotting often resembling the stars and constellations that are so vivid in the desert sky.

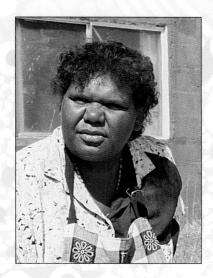

I was born in Alice Springs in 1975. I grew up with my grandfather and grandmother and lived in the old houses area of Santa Teresa before the new houses were built. I went to school here at Santa Teresa and finished school in year ten. After that I went to South Australia to visit my sister Belinda and her new baby girl. I then came back to Santa Teresa and got a job at the community store. I also worked at the women's centre and then at the community club. I didn't really like the jobs in any of these places.

I went to see what my mother, Laurencia, and my auntie, Bridgette Wallace, were doing up at Keringke Arts. They were painting designs on boxes, paper, stools and other things as well. I said that I would like to work there and they told me to ask Kathleen Wallace. I did that, and then I stayed there and worked. First I started painting shorts, shoes, bracelets, heart-shaped boxes and coffee tables. I always used my own designs, but sometimes asked Bridgette or Kathleen to help me. The more I work, the more my designs are truly my own.

Sharon Williams

Vibrant colours and a repetition of visual elements combine to produce fluid and striking designs in Sharon Williams' work. Sharon's designs and use of colour reflect her enthusiastic approach to painting and her vibrant personality. In many of her works, radiating lines connect with circles of dots, perhaps offering an abstract map of pathways through country, but also often resembling plants as they flower.

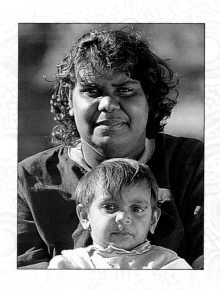

Mrs Wallace showed me how to do painting when I first started. She helped me out on some designs, showing me her style. Now, after working here for a few years, I have my own designs and my own style.

Sometimes my family goes to Central Land Council meetings. My dad takes us along and sometimes the meetings go on for two weeks, or a week, or just two days. My dad shows us the country. It's always good to go to our homelands. Whenever my baby gets sick, I go out to find bush medicine. We still use bush medicine for sores.

I was born at Santa Teresa and also went to school here at the mission. In later years, I went away with a few other girls to Townsville to go to school. I was there for two years and did up to year eleven. After that, I came back to Santa Teresa. I looked around for a job and then got one at the school. After that I worked in the shop for about two years. From there, I decided I'd try Keringke Arts. At first I thought I would just try it out, to see how I would go, but I liked it and stayed. I started doing designs on giftboxes and then on small silks, learning as I went along. Kwementyaye Rockchild was the coordinator then.

We have a new coordinator now. His name is Tim Rollason. Some things have changed a lot since he's been here. We are now doing lots of work for exhibitions here at Keringke Arts. They are held in Sydney and Alice Springs and all over Australia. For the exhibitions, we do things like papers and silk lengths, chairs and silk paintings. Everything is running smoothly.

List of artworks

Plate 1
Kathleen Wallace
Dancing Women, 1997
acrylic on paper
55 x 37 cm

Plate 2
Kathleen Wallace
Arelhe Altyerrenge Alhe Aneke
(Woman from the Dreamtime), 1997
acrylic on canvas
76 x 50 cm

Plate 3
Kathleen Wallace
Irrernte-arenye Singing, 1997
silk painting
2 x 1.15 m
Collection of the
National Gallery of Victoria

Plate 4
Kathleen Wallace
Kwelaye (Rainbow Snake), 1997–1998
acrylic on canvas
78.5 x 124 cm

Plate 5
Kathleen Wallace
Untitled, 1997
silk painting
2 x 1.15 m
Collection of the
National Gallery of Victoria

Plate 6
Kathleen Wallace
Atyemeye-kenhe Impatye
(Grandfather's Tracks), 1996
silk painting
2 x 1.15m

Plate 7
Bridgette Wallace
Untitled, 1997
acrylic on paper
37 x 27 cm

Plate 8
Bridgette Wallace
Untitled, 1997
silk painting
90 x 90 cm

Plate 9
Bridgette Wallace
Untitled, 1996
silk painting
90 x 90 cm

Plate 10
Bridgette Wallace
Untitled, 1997
acrylic on paper
66 x 51 cm

Plate 11
June Smith
Untitled, 1998
silk painting
90 x 90 cm

Plate 12
June Smith
Untitled, 1998
acrylic on paper
27 x 37 cm

Plate 13
Mary Oliver
Untitled, 1998
acrylic on paper
38 x 57 cm

Plate 14
Mary Oliver
Untitled, 1998
acrylic on paper
57 x 38 cm

Plate 15
Mary Oliver
Untitled, 1995
silk painting
25 x 25 cm

Plate 16
Mary Oliver
Untitled, 1995
silk painting
25 x 25 cm

Plate 17
Camilla Young
Untitled, 1997
silk painting
1.15 x 2 m

Plate 18
Camilla Young
Untitled, 1997
acrylic on paper
27 x 37 cm

Plate 19
Camilla Young
Untitled, 1997
silk painting
90 x 90 cm

Plate 20
Camilla Young
Untitled, 1997
silk painting
2 x 1.15 m

Plate 21
Marie Young
Untitled, 1997
acrylic on paper
55.5 x 71.5 cm

Plate 22
Marie Young
Untitled, 1998
silk painting
90 x 90 cm

Plate 23
Marie Young
Untitled, 1998
silk painting
90 x 90 cm

Plate 24
Marie Young
Untitled, 1997
silk painting
2 x 1.15 m

Plate 25
Marie Young
Untitled, 1997
acrylic on linen
120 x 80 cm

Plate 26
Jane Oliver
Untitled, 1997
acrylic on paper
55 x 75 cm

Plate 27
Jane Oliver
Untitled, 1997
acrylic on desert oak
20 x 13.5 cm

Plate 28
Jane Oliver
Untitled, 1997
acrylic on desert oak
13.5 x 13.5 cm

Plate 29
Jane Oliver
Untitled, 1996
acrylic on paper
74 x 54 cm

Plate 30
Jane Oliver
Untitled, 1997
silk painting
1.15 x 2 m

Plate 31
Jane Oliver
Untitled, 1997
acrylic on paper
37 x 27 cm

Plate 32
Serena Hayes
Untitled, 1997
acrylic on desert oak
13.5 x 13.5 cm

Plate 33
Serena Hayes
Untitled, 1997
acrylic on desert oak
13.5 x 13.5 cm

Plate 34
Serena Hayes
Untitled, 1997
acrylic on paper
27 x 37 cm

Plate 35
Serena Hayes
Untitled, 1997
acrylic on paper
37 x 55 cm
Acquired by the Araluen Centre for
Arts & Entertainment, Alice Springs

Plate 36
Bernadette Wallace
Untitled, 1997
acrylic on desert oak
13.5 x 13.5 cm

Plate 37
Bernadette Wallace
Untitled, 1997
acrylic on paper
28.5 x 38.5 cm

Plate 38
Sharon Williams
Untitled, 1997
acrylic on paper
55 x 75 cm

Plate 39
Sharon Williams
Untitled, 1997
acrylic on desert oak
20 x 13.5 cm

Plate 40
Sharon Williams
Untitled, 1998
acrylic on paper
37 x 27 cm

Plate 41
Sharon Williams
Untitled, 1998
acrylic on paper
37 x 27 cm

Plate 42
Marie Young
Table, 1996
acrylic and varnish on wood
52 x 76 x 38 cm

Plate 43
Bridgette Wallace
Chair, 1996
acrylic and varnish on wood
87 x 42 x 42 cm

Plate 44
Sharon Williams
Vase, 1997
paint and varnish on terracotta
23 x 18 cm diameter

Plate 45
Bridgette Wallace
Bowl, 1996
acrylic paint and varnish on terracotta
5 x 25 cm diameter

Exhibitions

1988 *Apmere*, Birukmarri Gallery, Fremantle WA
Australian Bicentennial Craft Show, Sydney Showground, Sydney NSW

1989 *One Country, Two Views*, Araluen Centre for Arts & Entertainment, Alice Springs NT
Australian Craft Show, Sydney Showground, Sydney NSW
Northern Territory Art Award, Araluen Centre for Arts & Entertainment, Alice Springs NT

1990 *Mpwellare*, Araluen Centre for Arts & Entertainment, Alice Springs NT
Winter Wearables: Contemporary Aboriginal Designers, Tjilbuke Gallery, Tandanya, Adelaide SA

1991 *Crossroads*, Araluen Centre for Arts & Entertainment, Alice Springs NT
Aboriginal Women's Exhibition, Art Gallery of New South Wales, Sydney NSW
Central Australian Aboriginal Art and Craft Exhibition, Araluen Centre for Arts & Entertainment, Alice Springs NT

1992 Central Australian Aboriginal Art and Craft Exhibition, Araluen Centre for Arts & Entertainment, Alice Springs NT
Atyelpe, Te Taumata Gallery, Auckland NZ

1993 Central Australian Aboriginal Art and Craft Exhibition, Araluen Centre for Arts & Entertainment, Alice Springs NT
Northern Territory Art Award, Darwin NT
Central Desert Silks, Rainbow Serpent Gallery, Sydney NSW
Blundstone Boot Exhibition, Contemporary Art Service Tasmania, Hobart TAS

1994 Central Australian Aboriginal Art & Craft Exhibition, Araluen Centre for Arts & Entertainment, Alice Springs NT
Heritage Namatjira Exhibition, Tandanya, Adelaide SA

1994 National Aboriginal & Torres Strait Islander Art Award, Parliament House ACT
Alice Craft Acquisition, Araluen Centre for Arts & Entertainment, Alice Springs NT

1995 Alice Craft Acquisition, Araluen Centre for Arts & Entertainment, Alice Springs NT
National Aboriginal Art Award, Museum & Art Gallery of the Northern Territory, Darwin NT

Central Australian Aboriginal Art & Craft Exhibition, Araluen Centre for Arts & Entertainment, Alice Springs NT
Collegiate Arts Festival, Museum of Central Australia, Alice Springs NT
Fremantle Print Award, Fremantle Arts Centre, Fremantle WA
Northern Territory Art Award, Araluen Centre for Arts & Entertainment, Alice Springs NT
Cafe Gallery, Fremantle Arts Centre, Fremantle WA

1996 *Native Titled Now*, Tandanya, Adelaide SA
National Aboriginal & Torres Strait Islander Heritage Art Award, Old Parliament House ACT
National Fringe 1996, Inbarendi Fringe Gallery, Adelaide SA
Alice Craft Acquisition, Araluen Centre for Arts & Entertainment, Alice Springs NT
Central Australian Aboriginal Art & Craft Exhibition, Araluen Centre for Arts & Entertainment, Alice Springs NT
National Aboriginal & Torres Strait Islander Art Award, Museum & Art Gallery of the Northern Territory, Darwin NT
Arm Load of Art Exhibition, Woods Street Gallery, Darwin NT
National Craft Acquisition Award, Museum & Art Gallery of the Northern Territory, Darwin NT
Great Lengths, Araluen Centre for Arts & Entertainment, Alice Springs NT
Anwernekenhe Tyepetye—Telling Our Story, Rainbow Serpent Gallery, Sydney NSW

1997 National Aboriginal & Torres Strait Islander Art Award, Museum & Art Gallery of the Northern Territory, Darwin NT
Desert Mob Art Show, Araluen Centre for Arts & Entertainment, Alice Springs NT

1998 *Keringke Arts: Designs of the Desert*, Hogarth Galleries Aboriginal Arts Centre, The Rocks, Sydney NSW
Desert Mob Art Show, Araluen Centre for Arts & Entertainment, Alice Springs NT
Keringke Arts, National Aboriginal Cultural Centre, Sydney NSW
Keringke Arts: Colour and Light, Gondwana II, Alice Springs NT
Keringke Arts: Kaleidoscope, Framed—The Darwin Gallery, Darwin NT

Collections

Flinders University Art Museum, Adelaide SA
Handpainted canvas chair and boomerang by Carol Young
Watercolour paintings by Kathleen Wallace, Gabriella Wallace and
Therese Ryder

Queensland Art Gallery, Brisbane QLD
Three handpainted silk lengths, 300 x 96 cm, by Mary Oliver,
Jane Oliver and Bridgette Wallace

Crafts Council of the Northern Territory, Alice Springs NT
Painted coolamon by Kathleen Wallace
Two works on silk, 90 x 90 cm, by Kathleen Wallace and Mary Oliver

Kelton Foundation, Los Angeles USA
Silk length, 4.24 x 1.15 m, by Kathleen Wallace

Araluen Centre for Arts & Entertainment, Alice Springs NT
Collection of works representing the history and artists of Keringke Arts

National Gallery of Victoria, Melbourne VIC
Two silk lengths, 1.15 x 2 m, by Kathleen Wallace